Remembering

St. Petersburg

Andrew N. Edel

TURNER

PUBLISHING COMPANY

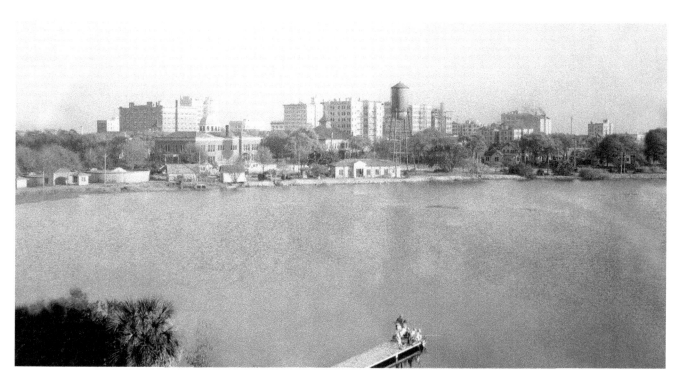

Shown here in 1926, beautiful Mirror Lake supplied most of the city's fresh water from early days forward. As the city outgrew this source, the Cosme-Odessa basin, some thirty miles away, was tapped to supply St. Petersburg's water. Twelve wells and 26 miles of 36-inch pipe were capable of supplying 14 million gallons of water daily.

Remembering
St. Petersburg

Turner Publishing Company
4507 Charlotte Avenue • Suite 100
Nashville, Tennessee 37209
(615) 255-2665

Remembering St. Petersburg

www.turnerpublishing.com

Library of Congress Control Number: 2010924325

ISBN: 978-1-59652-671-6

Printed in the United States of America

ISBN: 978-1-68336-886-1 (pbk)

10 11 12 13 14 15 16—0 9 8 7 6 5 4 3 2 1

CONTENTS

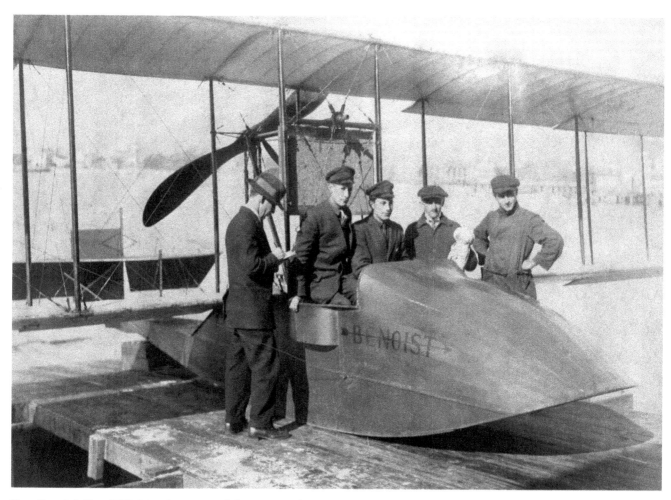

Tom Benoist's Type XIII flying boat merged the wings, tail, and engine of his Type XII airplane to a boat-hull style fuselage. Percy Fansler proposed to Benoist to use flying boats for an airline service between St. Petersburg and Tampa. Fansler arranged the financial support while Benoist built an improved flying boat, the larger Type XIV.

Acknowledgments

This volume, *Remembering St. Petersburg,* is the result of the cooperation and efforts of many individuals and organizations. It is with great thanks that we acknowledge the valuable contribution of the following for their generous support:

Library of Congress
St. Petersburg Museum of History
State Archives of Florida

PREFACE

The photographic history of St. Petersburg is well documented thanks in large part to the founding of the St. Petersburg Historical Society in 1920. Numerous books with historic photographs of St. Petersburg have been published, thousands of area photographs are available online at the Florida Photographic Archives, and thousands of additional photographs are on Web sites. Why another book of historic photographs of St. Petersburg?

There are two compelling reasons. First, because of the sheer numbers of extant photographs, even those familiar with the city's history will likely find new images. Those unfamiliar with the city's past will get a fresh glimpse into the rich photographic history of the community. Second, in addition to its unique compilation of photographs, every book offers its own focus of interest and commentary on each photograph included. The focus of this volume is on the development of St. Petersburg through the drive, spirit, and optimism of its citizens, allowing the viewer to visually experience the continuity of St. Petersburg's past and present. As one of the nation's largest metropolitan areas, St. Petersburg is a growing and vibrant city still luring thousands of tourists annually. For all those newcomers and tourists wishing to discover more about St. Petersburg, the goal of this work is to provide some insight and perspective about its traditions, history, people, and culture.

The photographs have been collected from the Florida Photographic Collection of the State Archives of Florida, the St. Petersburg Historical Society, and the Library of Congress. With the exception of cropping images where needed and touching up imperfections that have accrued over time, no other changes have been made. The caliber and clarity of many photographs are limited by the technology of the day and the ability of the photographer at the time they were made.

Individually, these photographs offer an unspoiled glimpse of another place and time along with informative text about specific elements, prompting the viewer to draw his own insights and interpretations. Arranged in chronological order, the individual photographs merge into a collective history of the various

aspects of the community's challenges, growth, and development. This collection is organized into four broad periods of time. In each era the selection of photographs together with their captions provide a broad perspective on the development of St. Petersburg. Various aspects are traced from period to period focusing on the economy, civic improvements, education, state government, and social trends. The photographs for section One, "Sunrise," span the initial founding and growth of the town to 1918. Section Two, "Sunny Skies," covers the boom years and its tremendous impact on city development. Section Three, "Overcast," deals with the subsequent bust in 1926 and moves into the years of the Great Depression. The last section, "Clearing Skies," starts with World War II and chronicles the postwar boom up to the mid-1960s.

Throughout the years St. Petersburg has prospered in large part owing to its successful crafting of an image as a city of sunshine. Since its inception it has profited from nationwide publicity and promotions designed to attract tourists and new residents. The image portrayed is not imaginary—the city is justifiably proud of its natural beauty and climate, the hospitable and friendly residents, and its rich cultural resources—but the dream and the reality are not always synonymous. Like any American city, the city has faced its share of challenges—control of growth, public financing, the struggle for civil rights, environmental concerns. As a resort community, the city has also had to cope with a fluctuating economy. In Nathaniel Hawthorne's classic short story "The Great Stone Face," a young boy grows to emulate the positive personal characteristics that he has projected onto a local geological feature. Similarly, St. Petersburg has developed by trying to live up to its own image, trying to be the perfect city it has promoted. Perhaps it will always fall just short of the goal, but at the same time it will always aspire to be the "Sunshine City."

By 1885, the lower Pinellas peninsula remained sparsely settled, and various families owned and had tried unsuccessfully to develop land in what is now St. Petersburg. In 1880 there was one general store and one post office in the hamlet of Big Bayou, and this drugstore. The general store had only $200 worth of items—among them sugar, grits, tobacco, coffee, and flour.

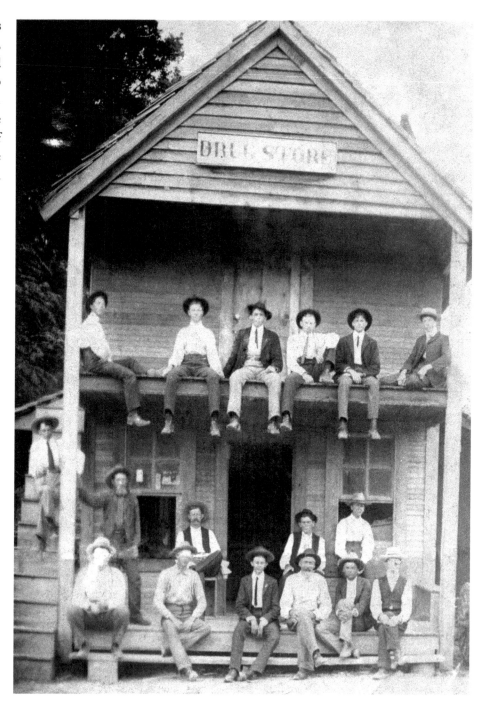

Sunrise: The Founding of the Sunshine City

(1888–1918)

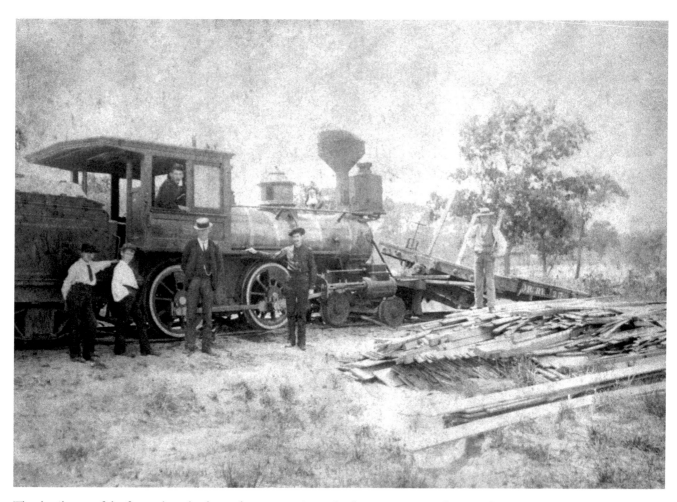

The derailment of the forward truck of an early steam engine and a flatcar prompts a photograph. In 1888 Peter Demens, alias Petrovitch A. Demenscheff, or "that redoubtable Russian hustler," extended the Orange Belt Railway to a point on the Pinellas Coast. A new town was founded at the terminus and named after Demens' birthplace of St. Petersburg, Russia.

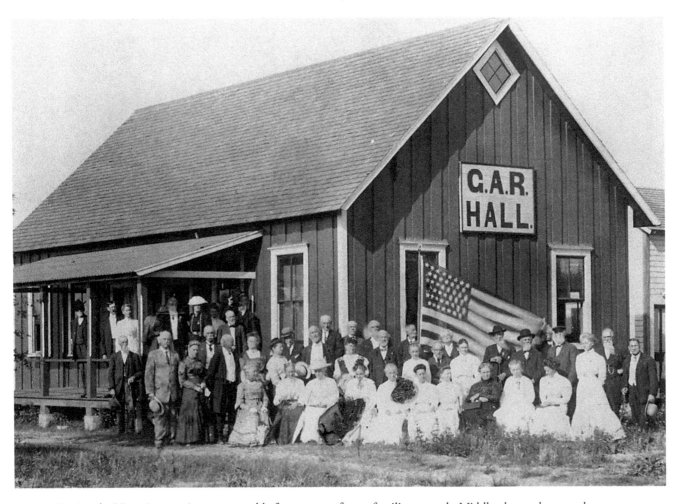

During the Victorian age, it was acceptable for women of poor families to work. Middle-class and upper-class women were expected to perform volunteer activities and church work. One of the first volunteer associations in the new town was the Women's Relief Corps of the Grand Army of the Republic.

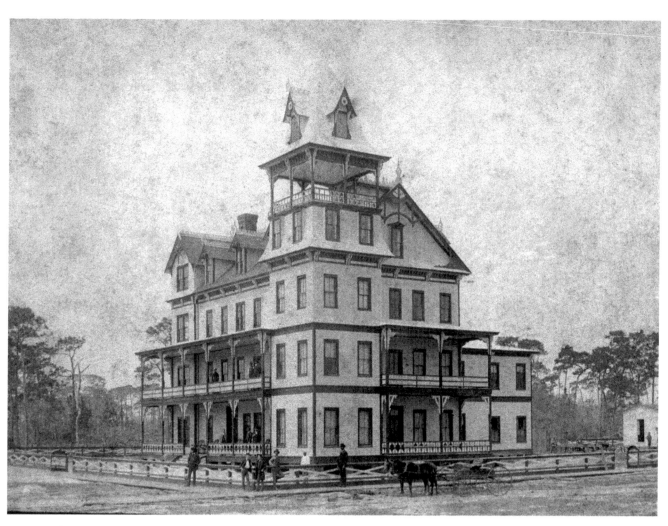

Imposing for a town of only 50, the Detroit Hotel, named after the hometown of John Williams, was part of the original deal between Williams and Peter Demens that founded St. Petersburg. Built by the Orange Belt Railway, the three-and-a-half-story hotel boasted 40 rooms, a 70-foot tower, and striking views of the bay.

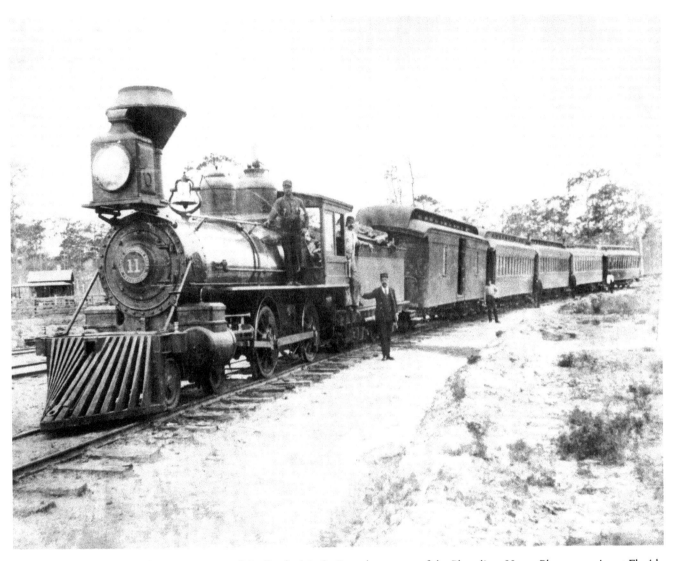

The crew poses with Engine no. 11 of the Sanford & St. Petersburg, part of the Plant line. Henry Plant, prominent Florida railroad owner, leased the financially troubled Orange Belt Railway in 1895. He renamed it and converted the narrow gauge to standard gauge in 1897, permitting an increase of rail traffic from the north.

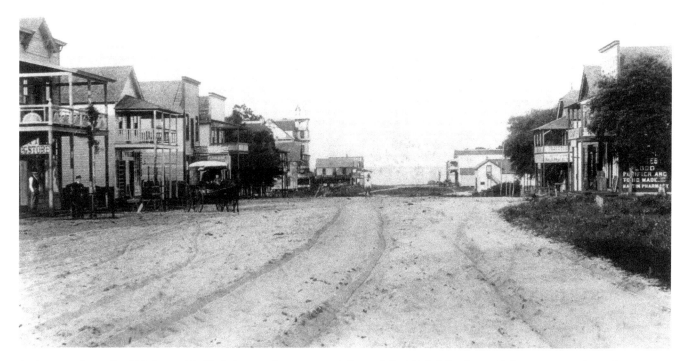

A view east down the 100-foot-wide Sixth Avenue (later renamed Central) in 1897. Like those of all new towns, the early streets were muddy, soggy, and almost impassable. Lacking city funds, St. Petersburg women took the initiative. Raising money through selling lemonade, ice cream, and sundries, they had sidewalks built.

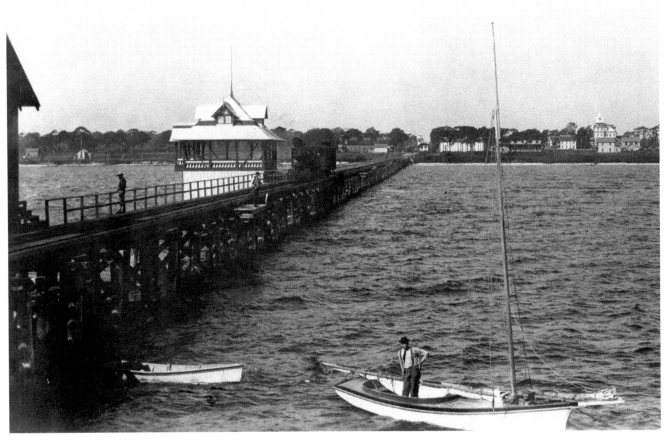

In an effort to attract tourists, the Orange Belt Railway constructed an ornate bathing pavilion on its pier in 1890. The pavilion had a toboggan slide and fresh water showers supplied by an artesian well. According to the *Times,* one feature of the bathhouse was "that you can get a fresh water bath after you take a dip in the briny blue." In this view, a steam engine approaches as fishermen at trackside try their luck.

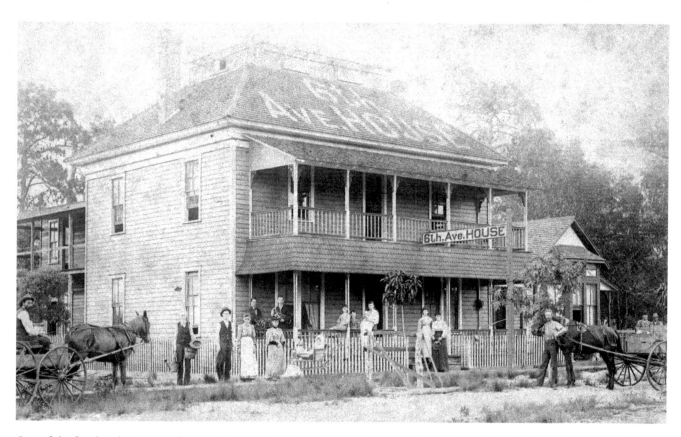

One of the first hotels in town, the popular Sixth Avenue House opened in 1893. George King bought it, remodeled it, and named it the Lakeview House. King advertised it in the *Strand Magazine* in England, stating that "we milk our own milk and lay our own eggs." King sold it in 1902 and it was renamed the Belmont.

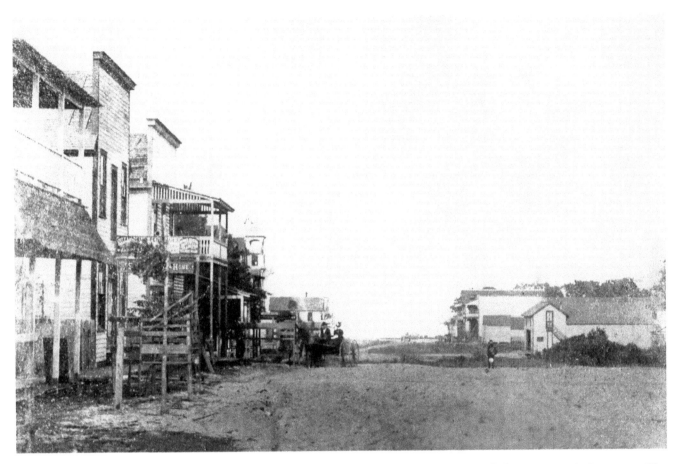

"The Swale," a large low area between Second and Third streets on Central Avenue, essentially became a pond after storms. The first sidewalks had to be raised over it. Borrowing money from the local bank, five city council members used the funds to have the Swale filled in 1894, permitting the east end of Central Avenue to prosper.

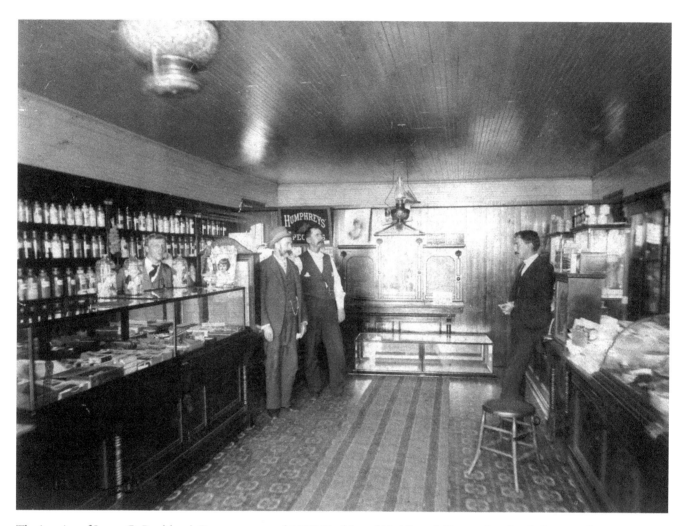

The interior of James G. Bradshaw's Drugstore around 1896. Bradshaw (third from left) served as the city's mayor from 1913 to 1916. The local paper boasted that the young town also had a bicycle shop, a steam laundry, two dairies, a small cigar factory, three general stores, two lawyers, and five doctors, but only one undertaker.

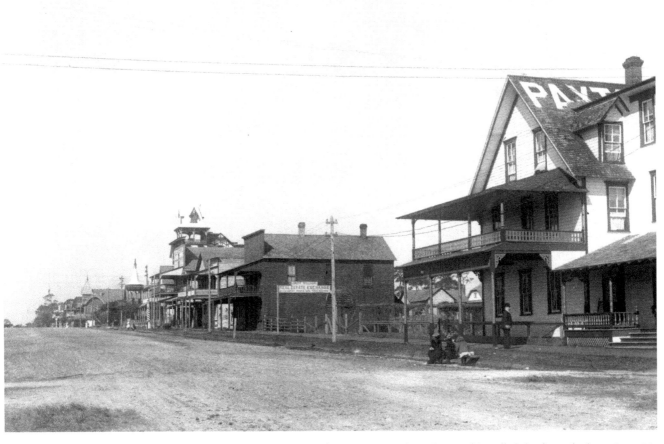

Wires along Central Avenue in 1900 attest to improving utility services. Arthur Norwood installed the first telephone in 1898, linking his two stores. A year later a small local system served 18 phones. The first utilities franchise was granted to Frank A. Davis, and his power plant started generating electricity in 1897.

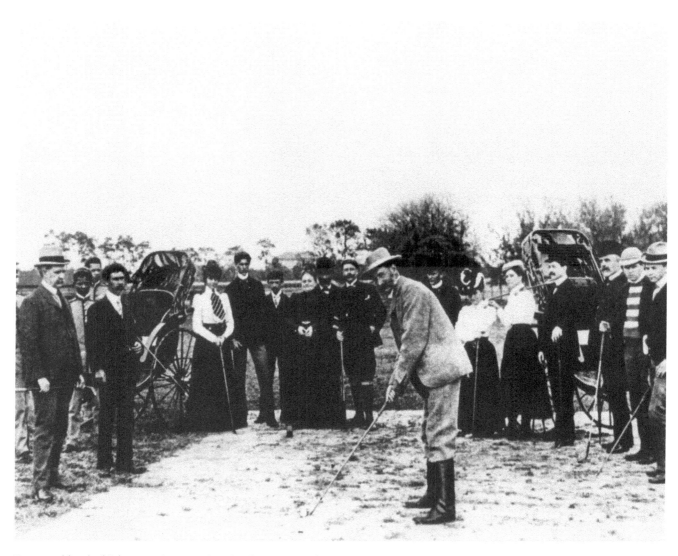

Frustrated by the high prices for waterfront land in St. Petersburg, Henry Plant changed his location for a grand hotel. The luxurious Belleview Hotel opened in Belleaire, south of Clearwater, in 1897. The Belleview's original nine-hole golf course had sand greens, but later added Florida's first grass greens.

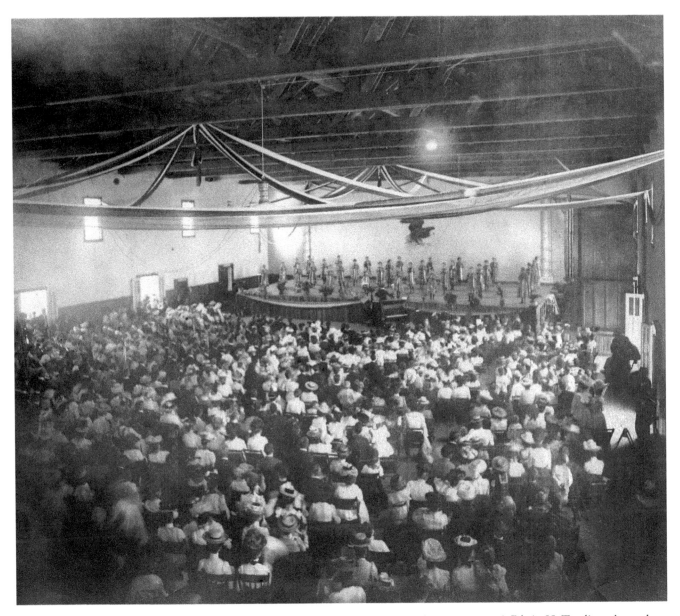

St. Petersburg schoolchildren celebrated Washington's Birthday, starting on February 22, 1896. Edwin H. Tomlinson's purchase of 250 silk flags for the first celebration helped ensure that it would become an annual winter event. A parade was followed by an indoor ceremony, performed by the schoolchildren.

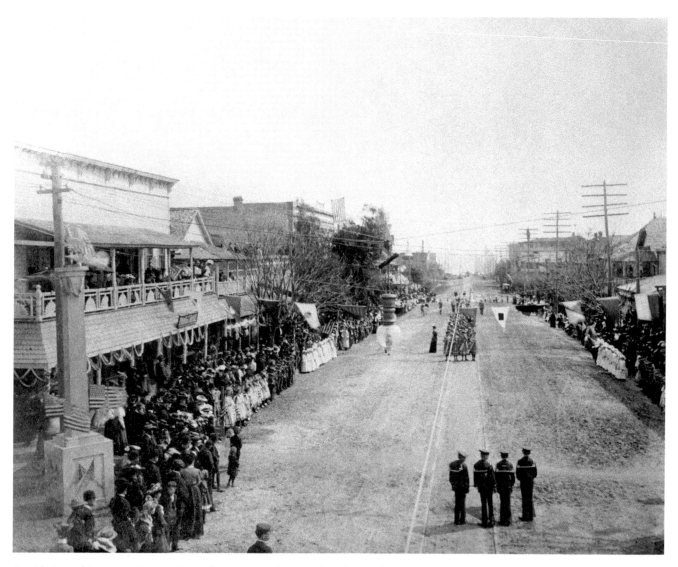

A midwinter fair association was formed in 1900, with 106 subscribers at $10 each. The fair opened in 1901 with a parade and a month-long exhibit. Its success prompted the construction of an auditorium, but the fairs failed a few years later. The auditorium was sold and each backer received $26 for his $10 investment.

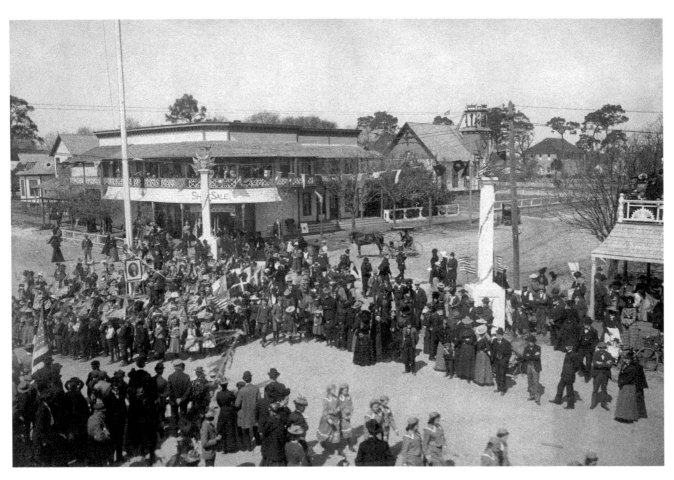

The school parade for Washington's Birthday Celebration passes the Durant block at the corner of Fourth Street and Central Avenue around 1901. Other activities included May pole parties, ceremonies, performances, and drill teams. The celebration was halted in 1914 because the school board felt that too much of the students' time centered on the activity.

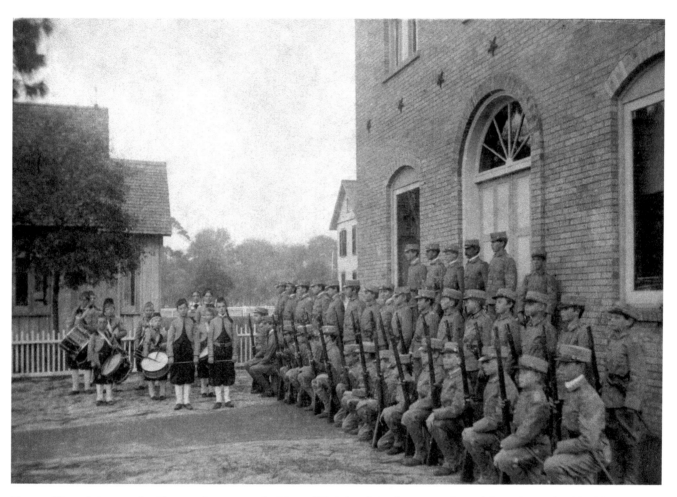

Zouave fife-and-drum and military cadets pose at the Manual Training School in 1902. One of the earliest school buildings in town, it was also used as a community center. The solidly constructed building with its one-foot-thick brick exterior walls was listed in the National Historic Register in 1999. It was still standing in 2007.

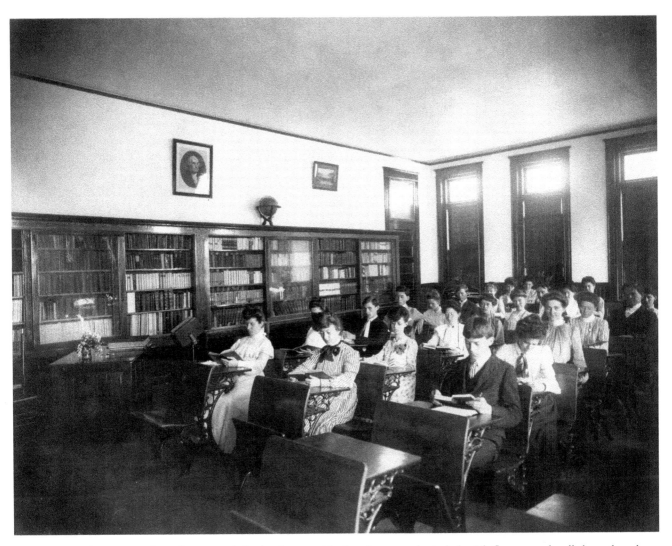

This 1902 classroom with its shiny new desks, bookcases with glass doors, teacher's desk with flowers, and well-dressed students may depict one of the first high school classes in the city. The St. Petersburg Normal and Industrial School opened in 1902 in a new brick building and was renamed St. Petersburg High School by 1904.

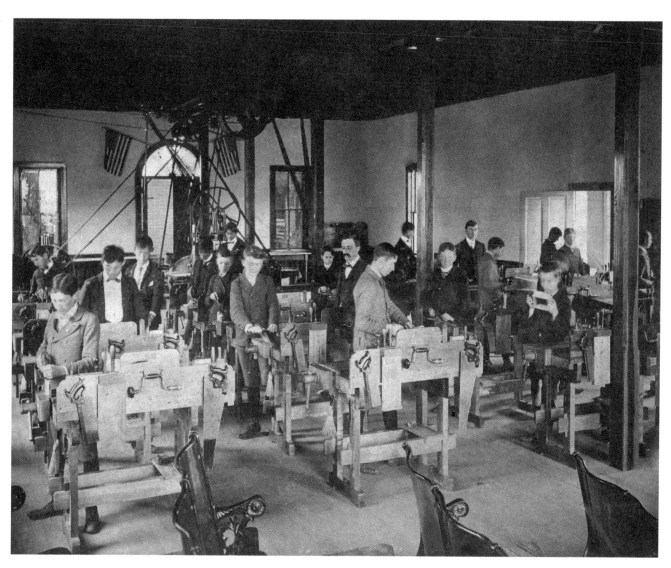

Students work on their projects at the Domestic Science and Manual Training School in 1903. Edwin H. Tomlinson provided $10,000 for the school, construction began in the spring of 1901, and it officially opened on December 29 of that year. The school provided valuable vocational training for youth, the first in Florida, until 1925.

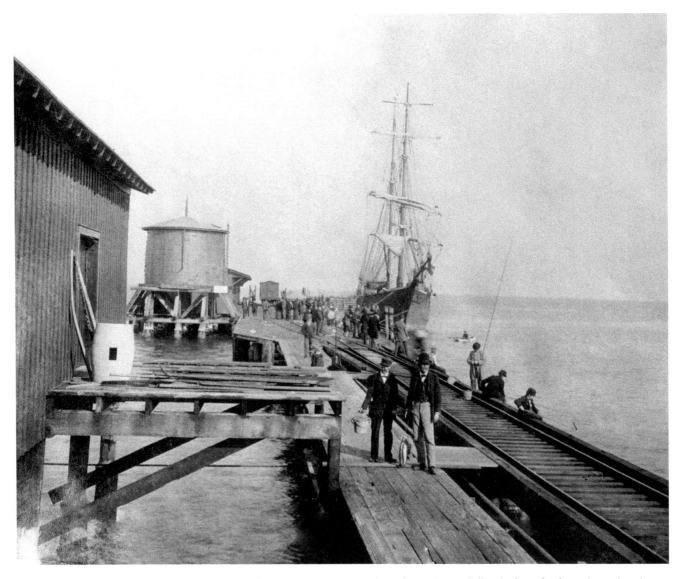

After acquiring the Orange Belt Railway and pier in 1895, Henry Plant charged a 25-dollar docking fee for independent boats. Control of the city's main pier gave Plant control over local commerce. Three years after Henry Plant's death in 1899, the railroad and pier became part of the Atlantic Coast Line.

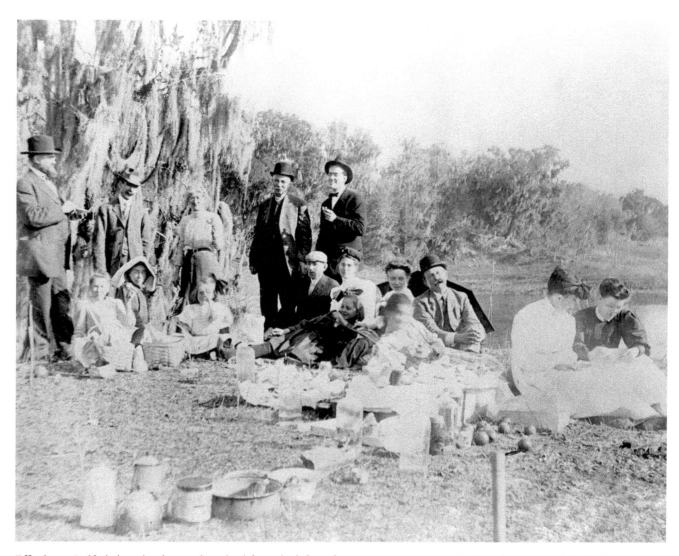

Effie Stone Rolfs, believed to be standing third from the left, with a party on picnic near St. Petersburg around 1910. Her husband, Dr. Peter Henry Rolfs, a prominent Florida botanist, served as director of the Florida Agricultural Experiment Station from 1906 until 1921, when he accepted an offer to found an agricultural college in Brazil.

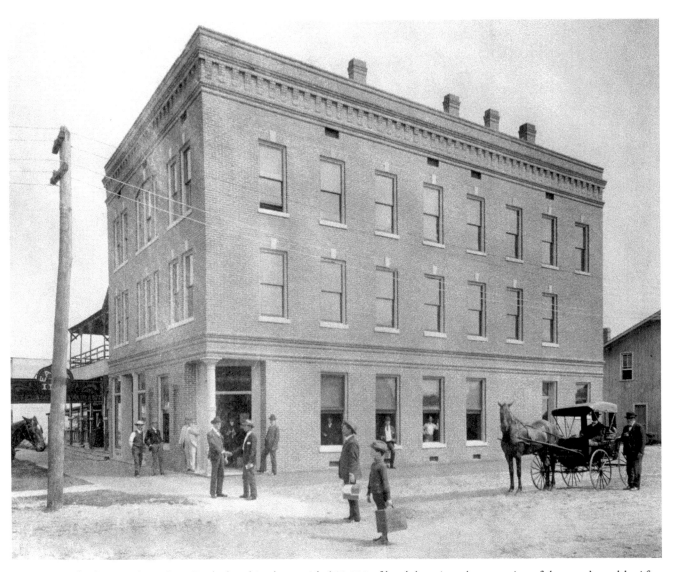

In 1902, the St. Petersburg State Bank closed its doors with $51,000 of local deposits, a large portion of the town's wealth. After years in court, the depositors received little of their money back. The new West Coast bank opened in this three-story brick building in 1903. Two years later it was renamed First National Bank.

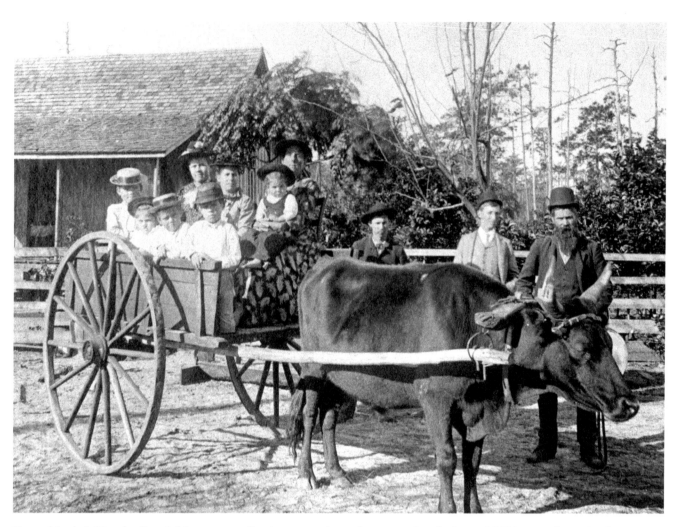

Dressed in their "Sunday Best," this party, traveling by ox-cart, is on the way to church. Around 1900 seven denominations had churches in St. Petersburg. Attempting to create a "good town," their combined influence had a significant effect on the community: no gambling joints, no red-light district, and a careful watch on saloons.

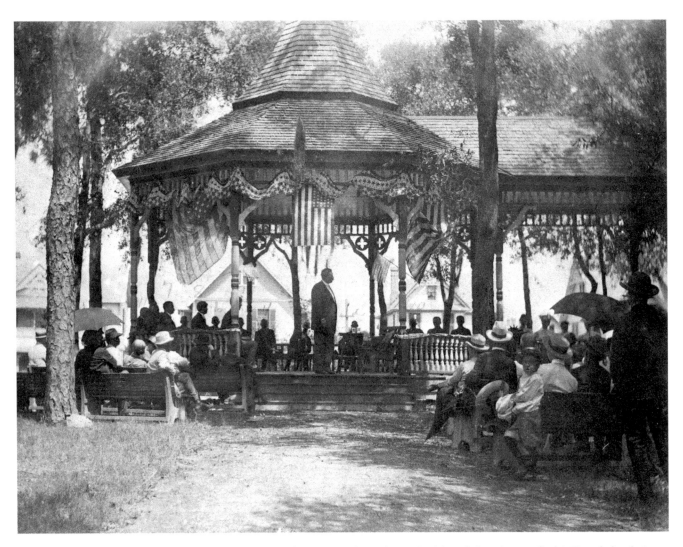

Napoleon Bonaparte Broward speaks at Williams Park on September 14, 1906. Although best-known for his Everglades drainage plan, Broward supported many reforms including better schools, a university system, good roads, prisons, a state library, and improved regulation of railroads and telegraph systems.

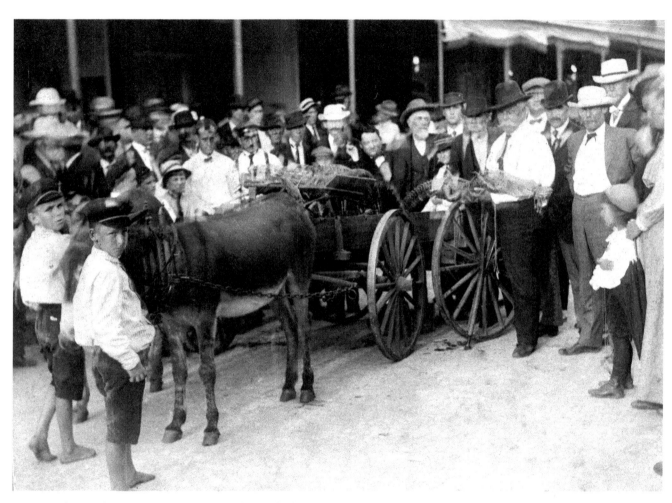

Young Hubert and Walter Coleman, again with a mule-drawn wagon, this time trying to cash in on the growing tourism boom. They would catch small alligators in Lake Maggiore and then transport them by wagon to downtown St. Petersburg, where for a nickel tourists could touch and hold them.

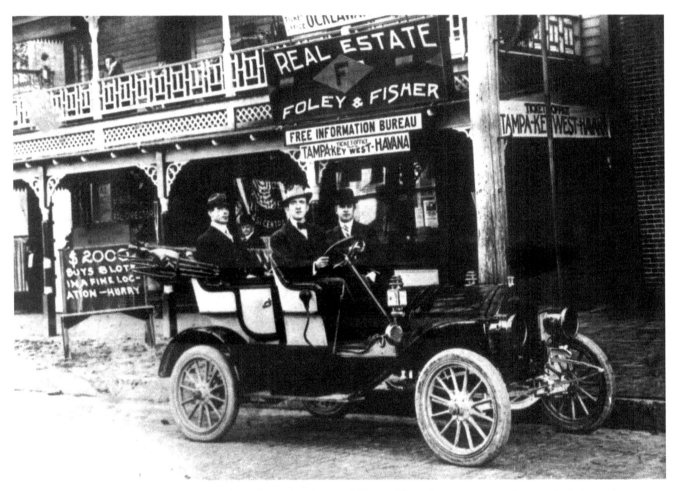

Offering a variety of "opportunities," the Foley and Fisher Real Estate office of 1908 promotes free tourist information, acts as travel agents, and advertises real estate lots. The sign behind the automobile announces, "$2000 buys 8 lots in a fine location—hurry." In 1905, Edwin Tomlinson, owner of the town's first automobile, occasionally drove along the new sidewalks when the city streets were impassable.

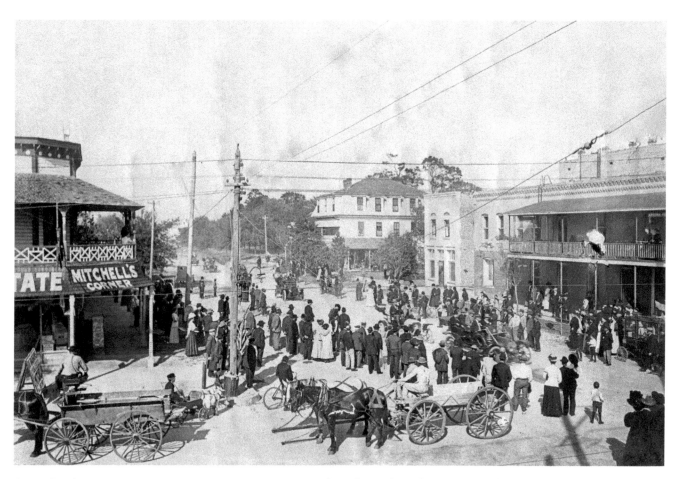

A crowd gathers to greet returning cross-country motorists. At far-right is Ed Tomlinson's original open-air post office. Mitchell's corner, at far-left, was built by Charles Durant in the early 1890s, then used as Arthur Norwood's department store. In the 1920s, it was the site of the towering Snell Arcade building.

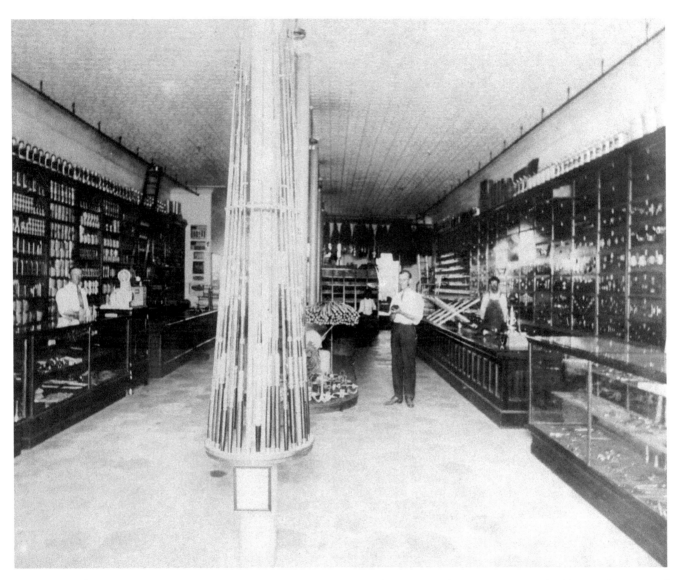

Tracy Lewis operated this Marine Supply store, shown here around 1910, out of his own two-story building at the corner of Central Avenue and 1st Street. The Lewis family was very active in the early development of St. Petersburg. Tracy's father, Fred Lewis, built the first house within the city limits, and his brother Edwin was a member of the city council.

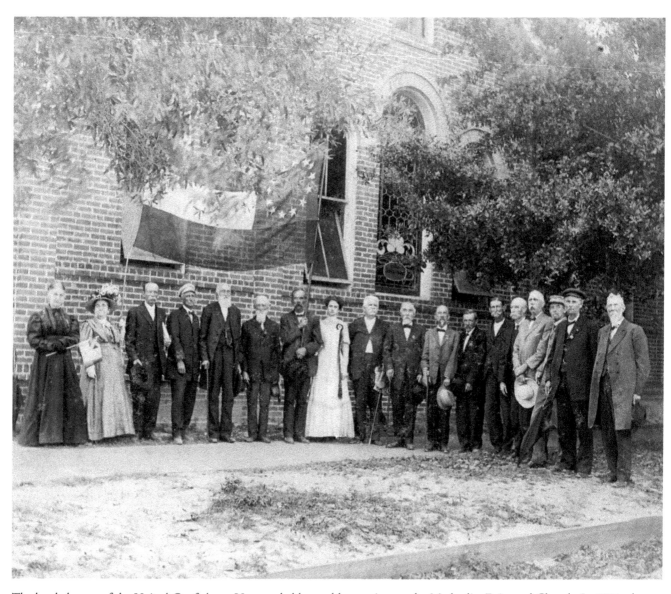

The local chapter of the United Confederate Veterans held monthly meetings at the Methodist Episcopal Church. In 1911, the Grand Army of the Republic objected to the Confederate flag in Washington's Birthday Parade. Some felt that only their age kept the two groups from fisticuffs and the disagreement was nicknamed the "Little Civil War."

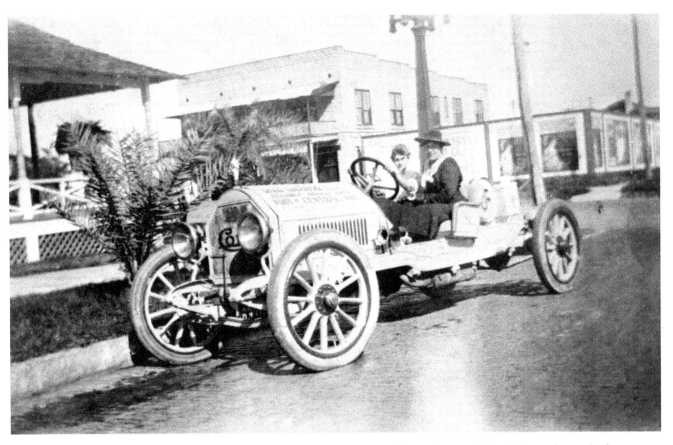

This early driver in St. Petersburg is visible evidence of the growing popularity of automobiles. This epoch saw the first garage, opened by Fred Ramm; the first filling station at Harrison Brothers hardware; and the first speeding ticket, a $100 fine to Mott Williams, for doing 18 miles an hour in a 10-mile-an-hour zone.

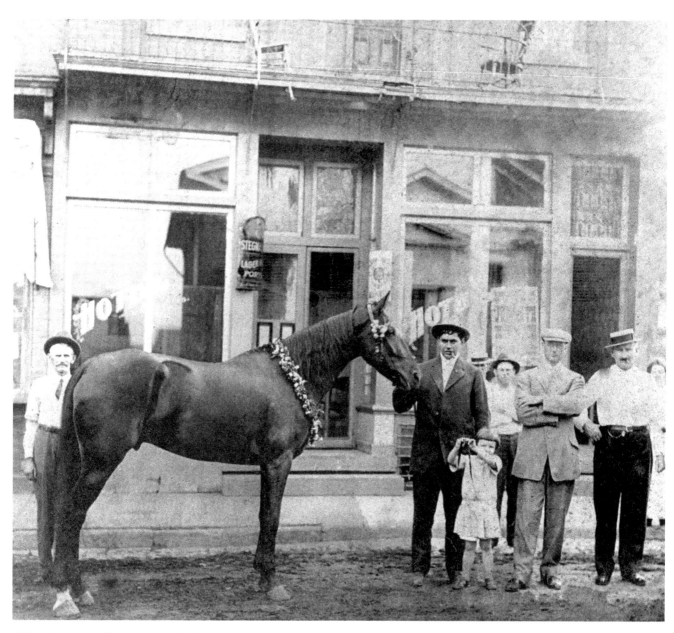

Although more and more automobiles were seen in St. Petersburg, horses were still very evident in town. Here local businessman Peter Sickler, at right in straw boater and white shirt, and Arthur Wiggins show off a beautiful horse. The decorations may be for a parade.

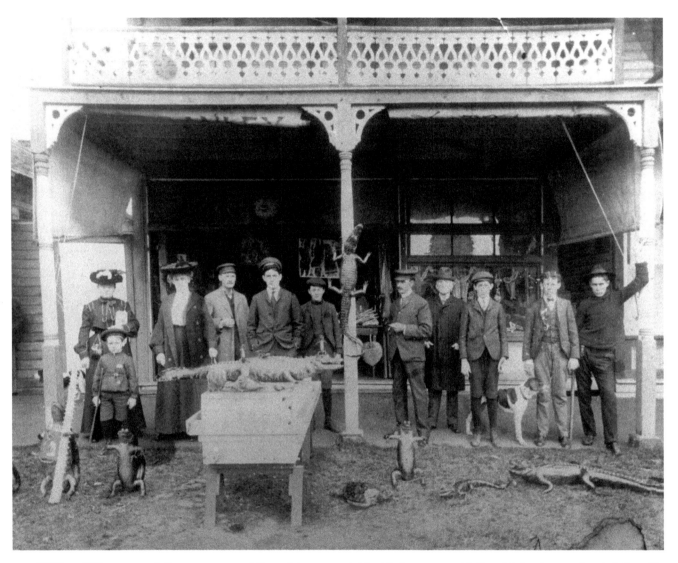

William "Alligator man" Carpenter, second from right, opened this gift shop next to his Royal Palm theater, the city's first. He often amazed tourists with live alligator shows. Four years later Carpenter took his alligator show on the road, touring the country with a six-foot alligator named Trouble and promoting St. Petersburg.

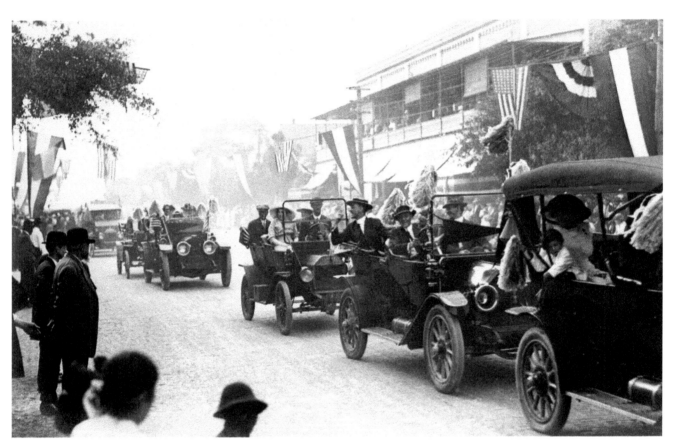

A 1912 publicity brochure declared, "St. Petersburg is an automobile town. The 100-foot wide streets paved with vitrified brick arouse the enthusiasm of visiting motorist." In the tract a visitor acclaimed, "The people are so energetic, sociable, friendly and free from snobbery and do so much for one's entertainment and amusement."

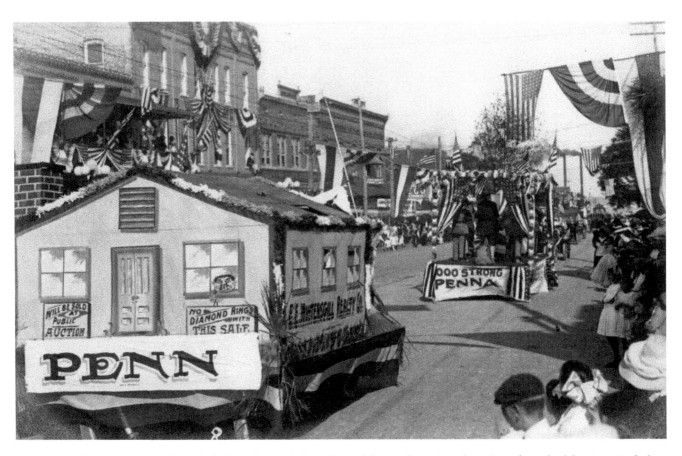

Between 1896 and 1914, St. Petersburg tried a variety of themes for various fairs, festivals, and celebrations, including Washington's Birthday celebrations, a midwinter fair, a Chautauqua assembly, the St. Petersburg Fair and Tourist Week, and a DeSoto celebration. The inaugural Festival of States parade was held in 1917.

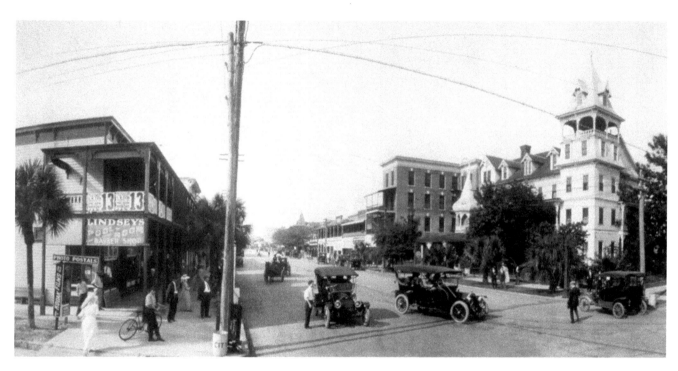

The stately Detroit Hotel dominates the corner of Central Avenue and Second Street. The 60-room brick addition was completed in 1914, bringing its room capacity to 100. W. S. Lindsey, owner of the pool room and barbershop across the street, became city police chief and county sheriff.

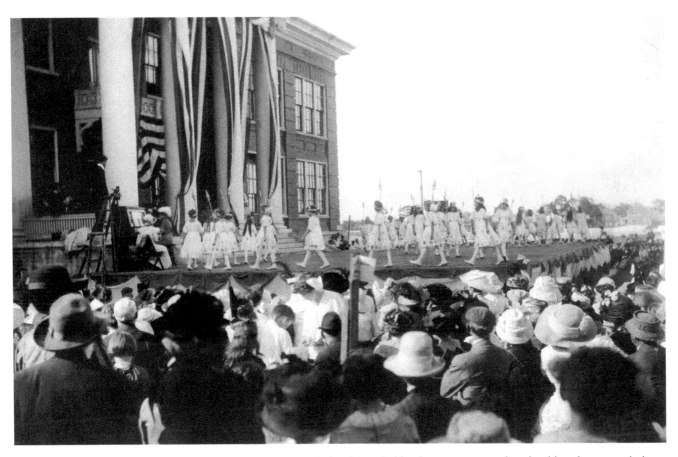

Students perform in front of the new St. Petersburg High School. Funded by the city in 1909, the school bond was struck down by the courts, since only counties not cities were then authorized to issue school bonds. The city transferred the bonds to local residents, who transferred them to Pinellas County after it was formed in 1911.

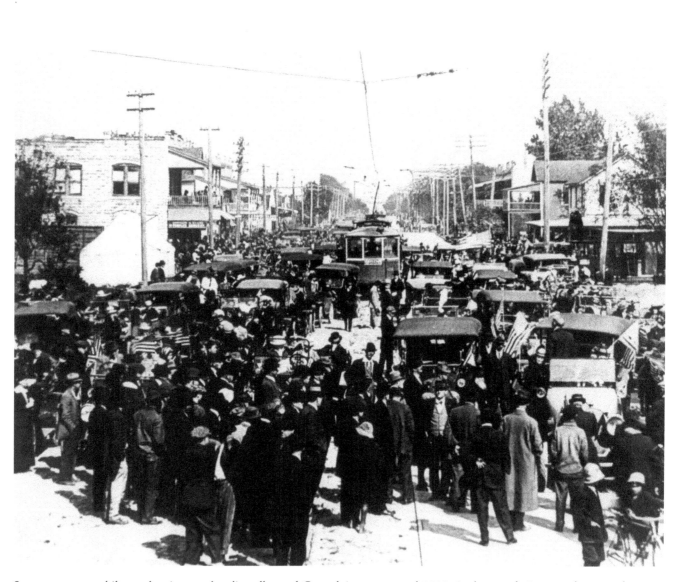

Streetcars, automobiles, pedestrians, and cyclists all crowd Central Avenue around 1913. As the population grew by more than ten thousand from 1910 to 1920, the streets became crowded and increasingly vital to the tourist industry. Accordingly, Central Avenue was paved with brick and officially reopened on March 23, 1914.

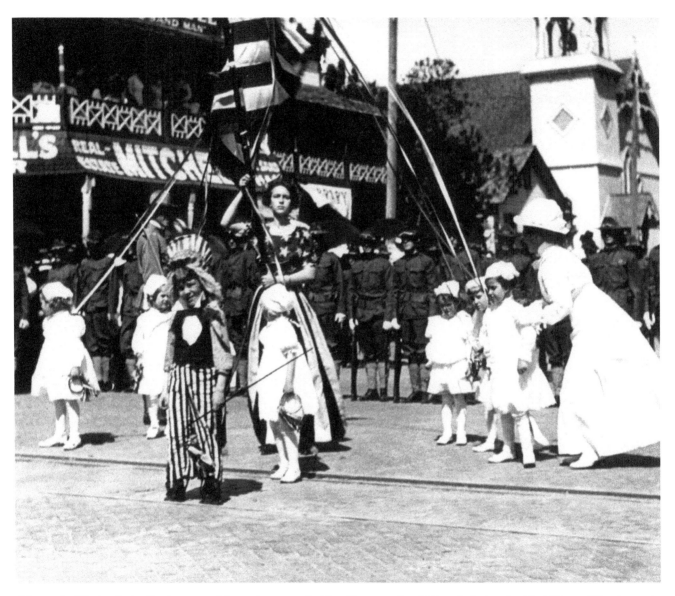

Marguerite Blocker is the flag bearer as this parade passes the First Congregational Church during the 1913 Fair and Tourist week. A 1912 promotional brochure described it as "a carnival time. Business is practically suspended . . . until the final day when the fair is closed by a grand parade of beautifully decorated autos and floats."

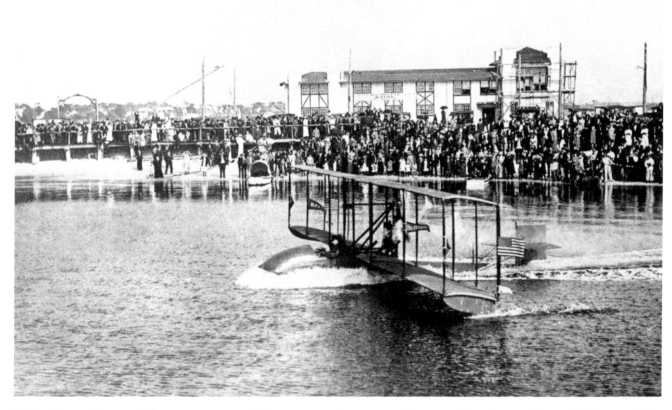

In this famous photograph from January 1, 1914, Tony Jannus pilots a Benoist Type XIV flying boat on the world's first regularly scheduled commercial airline flight. Former St. Petersburg mayor Abram Pheil won the auction to be the first passenger paying $400 for the 23-minute historic flight.

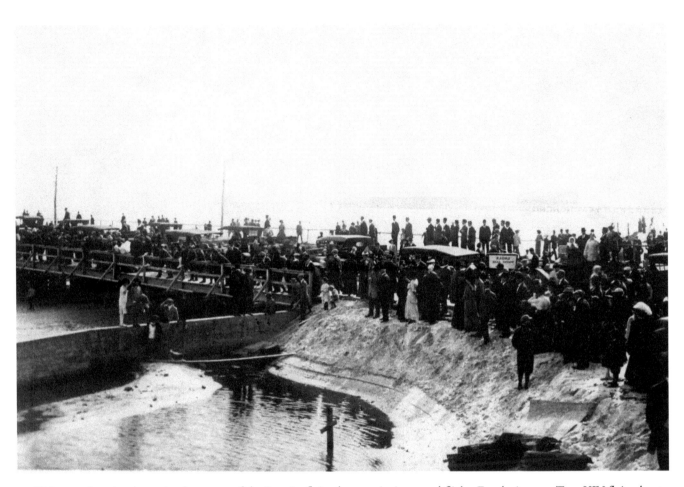

This crowd anxiously awaits the return of the Benoist flying boat on its inaugural flight. Employing two Type XIV flying boats, the airline flew service twice daily across Tampa Bay, charging $5 for a one-way ticket. When it folded in May 1914, the airline had carried 1,204 passengers without a serious accident.

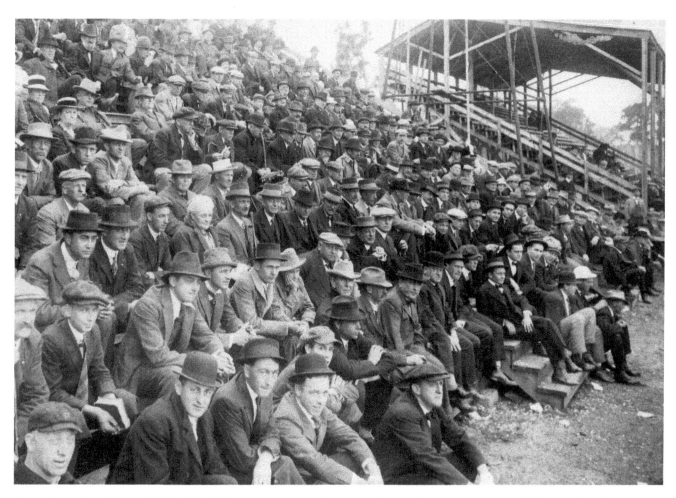

A crowd watches a Browns-Phillies baseball game in 1915. In the spring of 1914, the St. Louis Browns had trained in the area but did not return. Albert Lang then arranged to have the Philadelphia Phillies train in St. Petersburg, in the spring of 1915. The Phillies won the pennant that year and baseball remained in the fledgling city.

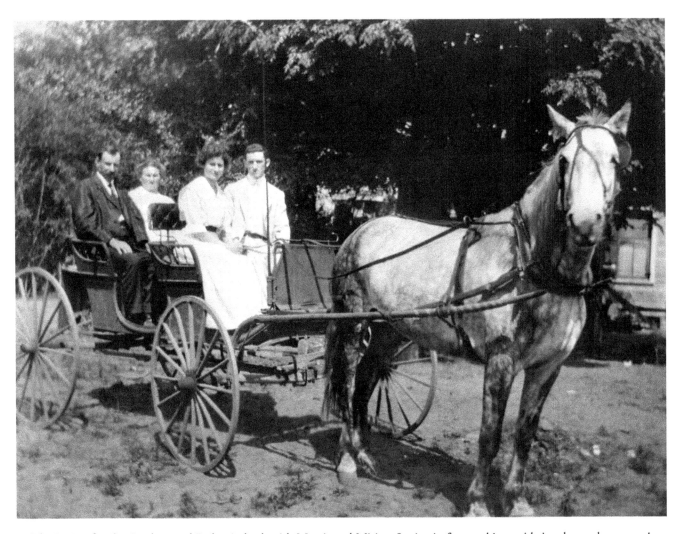

The Levine family, Gershon and Esther in back with Morris and Miriam Levine in front, taking a ride in a horse-drawn carriage around 1916. Counting only ten families by 1920, the twenties brought the first large influx of Jewish settlers and tourists and by 1926 the growing Jewish community finally had its own rabbi.

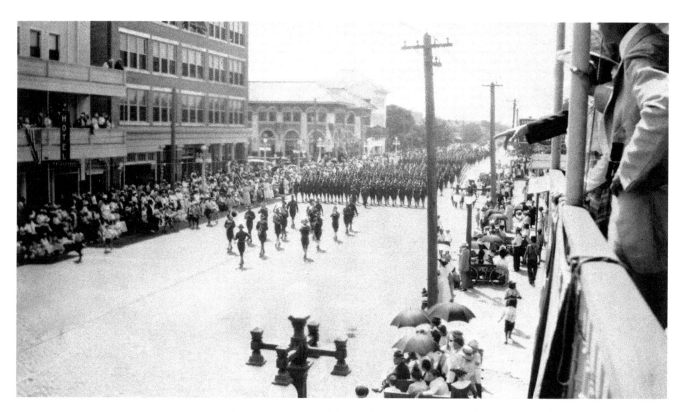

Soldiers parade down Central Avenue on February 22, 1918, while residents wave from porches and use umbrellas to shade themselves. The war was not the only problem facing St. Petersburg. Its economy struggled when the business empire of H. Walter Fuller faltered and went into receivership in April 1918.

Sunny Skies: The Boom Years

(1919–1926)

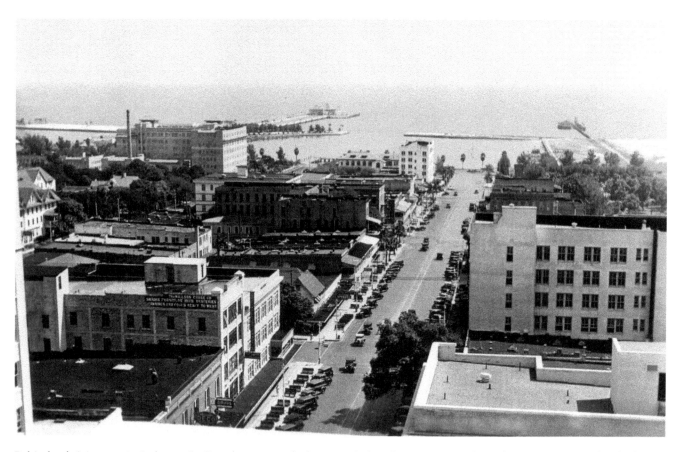

Behind a thriving tourist industry, St. Petersburg entered a boom period in the 1920s. East Central Avenue in 1922 already shows evidence of the prosperous and growing city—in stark contrast to the earlier dirt streets and wood storefronts. The new 85-room Ponce de Leon had just opened at the end of Central Avenue near the waterfront.

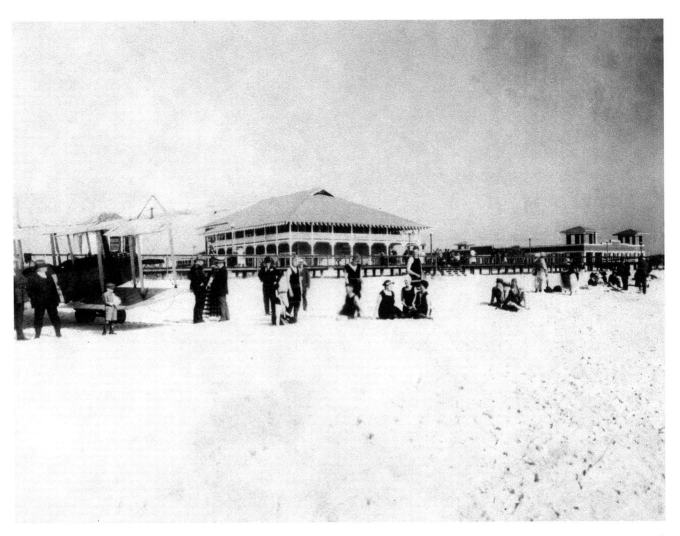

This biplane at St. Petersburg Beach around 1920, could be part of a stunt by Johnny Green, a local aviator who often took residents and tourists on their first flight. Before 1919, residents of St. Petersburg had preferred the readily available beaches of Tampa Bay to the Gulf beaches, which were accessible only by ferry.

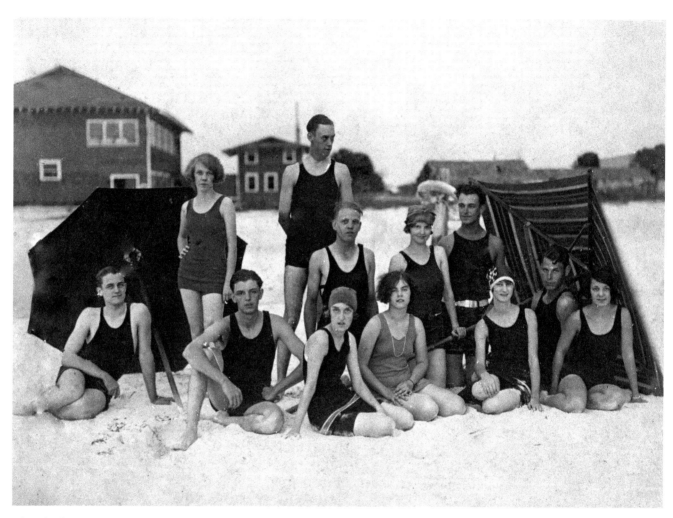

These bathers at St. Petersburg Beach in the 1920s may have used the new Pass-A-Grille bridge. Opened on February 4, 1919, and built by W. D. McAdoo, the wooden toll bridge instantly had a strong impact—with the new bridge in place, the gulf beaches at Pass-A-Grille and St. Petersburg Beach were only half an hour's drive from the city.

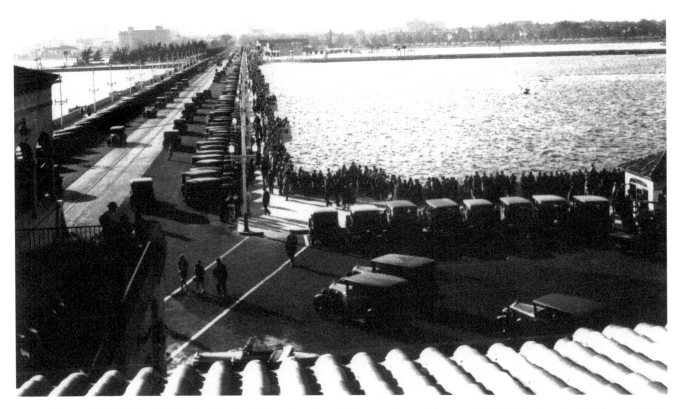

Facilities at the "Million Dollar Pier" included Spa Beach, a solarium, and a bait house. At 2,000 feet long by 100 feet wide, the two-lane road also had room for diagonal parking and fishing balconies. The street railway extended to the end of the pier, where the casino hosted dancing, concerts, and entertainment.

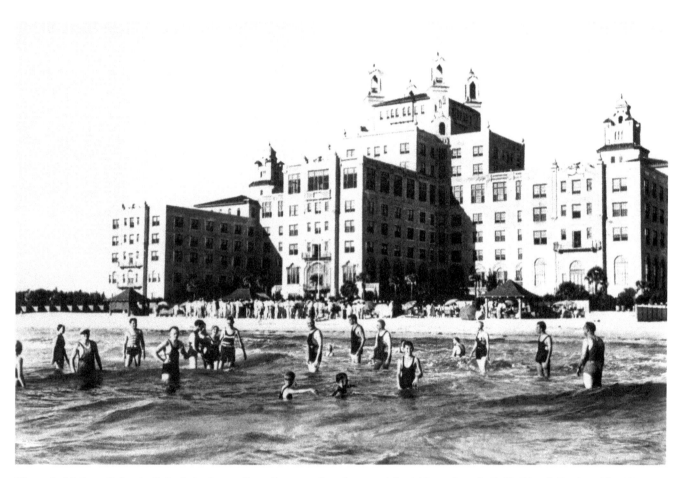

The palatial Don CeSar, built by John Rowe, formally opened on January 16, 1928, on Pass-A-Grille Island. Designed by Henry Dupont, the pink, 312-room hotel cost $1.5 million and entertained celebrities like F. Scott Fitzgerald, Clarence Darrow, and Babe Ruth. "Just imagine," reported an early guest, "there's a toilet and bath with every room."

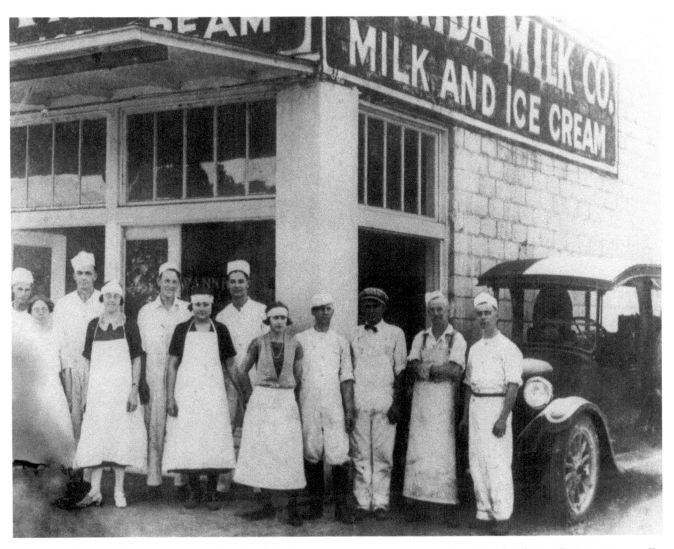

The Florida Milk Company, one of two local dairies, ran cattle on an open range they shared with Hood's Dairy. Reportedly, "feisty Elizabeth Hood" and "Cowboy Moody" fought over the strays. Moody tried to herd them to a city compound to collect a fee, while Mrs. Hood countered by roping the lead cow and leading the cows back to safety.

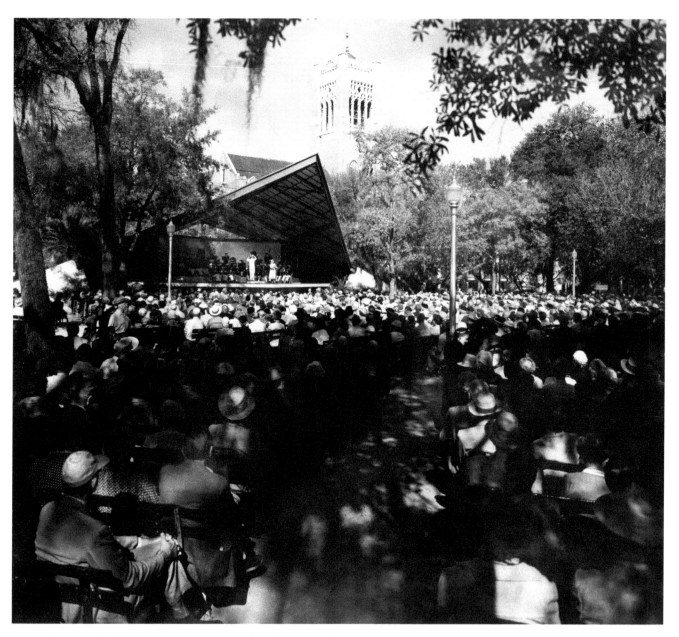

Erected in 1920 for $10,000, the new bandstand at Williams Park entertains a packed crowd, gathered for a band concert. The park became a sports center for horseshoes, chess, checkers, dominoes, and roque (a variety of croquet). After courts and lanes were built, the Williams heirs sued the city to keep the park open to the public. As a result, the sports clubs were relocated in 1923.

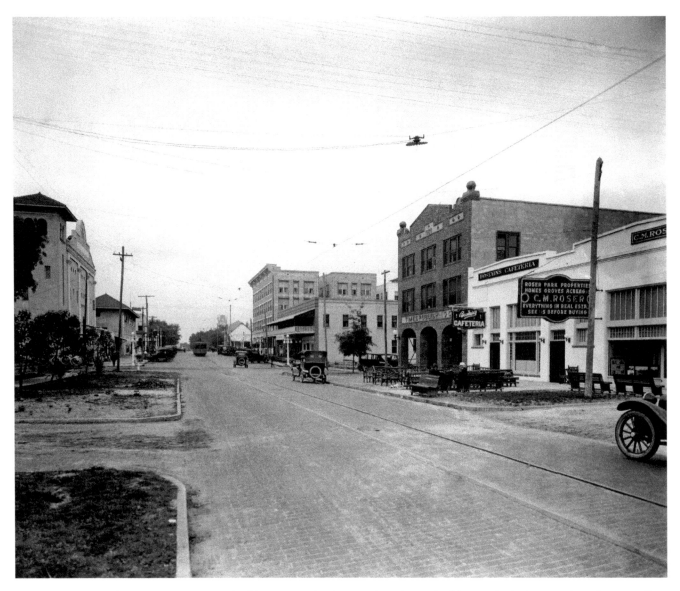

On the right, in this 1921 view of Fifth Street, is the St. Petersburg Times building and Charles Roser's Real Estate office. Opposite is the famous La Plaza Theater, built by George Gandy in 1913 at a total cost of more than $150,000. Towering over the city, it was initially dubbed "Gandy's White Elephant" but quickly became profitable.

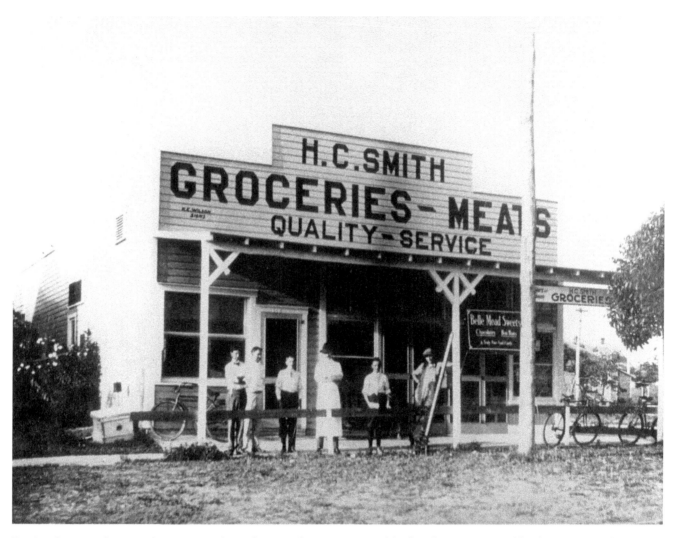

During the 1920s boom, a dozen new settlers a day moved into town. Neighborhood grocery stores, like this one, provided meats, fruits, and vegetables for the growing city. During the 1930s and 1940s, the "mom and pop" stores began to give way to larger supermarkets such as Nolen's Grocery, which boasted "6 car loads full of canned goods."

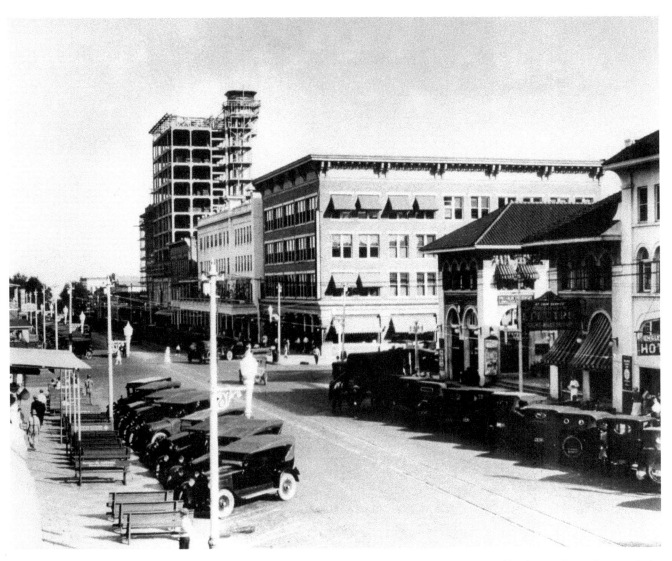

Between 1923 and 1926 ten new hotels were added to St. Petersburg to accommodate the sudden boom. Started in 1916, the eleven-story Pheil Hotel is still under construction in this view from 1922. Built by ex-mayor Abram Phiel, he died before it opened in 1924. It had gift shops, a domed ceiling, and a ground-floor theater.

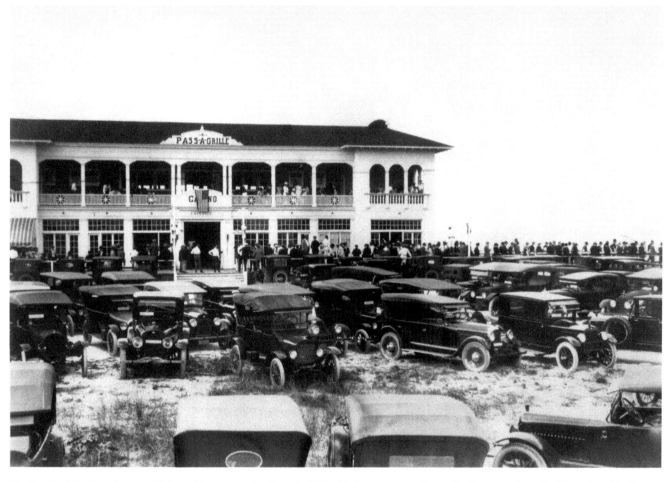

During Prohibition, liquor still found its way to the Pass-A-Grille Casino owing to Long Key's convenient Gulf location. In the area, rum sold for $20 a gallon, Canadian whiskey for $6 a quart, while moonshine fetched $5 a gallon. With set-ups supplied by the hotel, the drinks added to the casino's many conventions, parties, and dances.

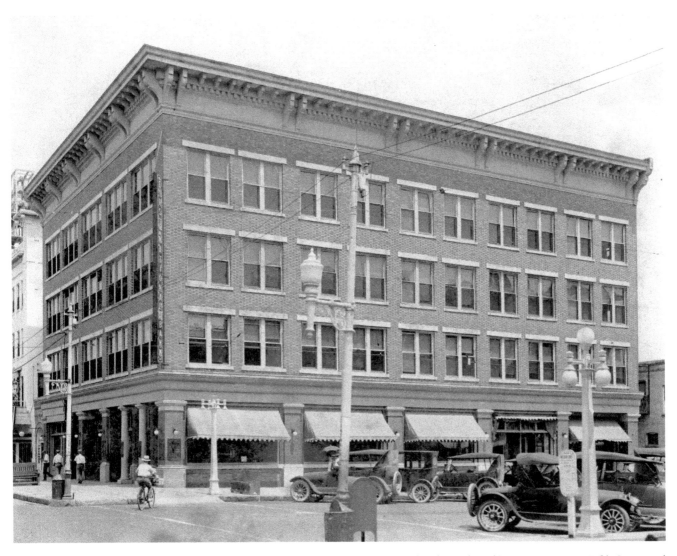

In 1920 the respectable First National Bank bought this building from the Florida Bank and Trust company at Fifth Street and Central Avenue. At the height of the boom era, bank deposits in St. Petersburg reached $46 million. This enabled First National Bank to enlarge the building to eight stories in 1925.

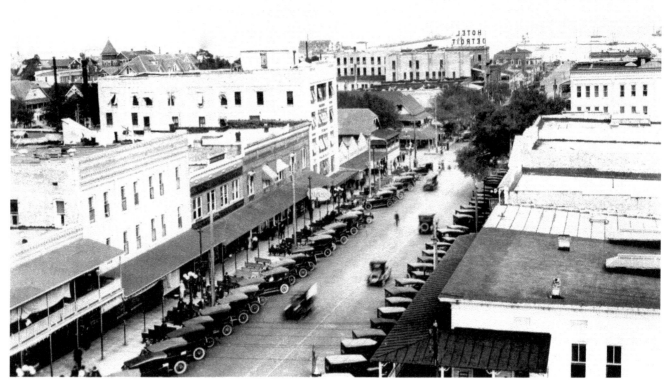

Visible on the left side of Central Avenue near the gulf, the Detroit Hotel is far from being the isolated building it was during its day as the only hotel in town. At the beginning of the boom, the town had fewer than 500 hotel rooms to handle the tourists and growing population. Between 1923 and 1926, seven large hotels were built in the downtown area.

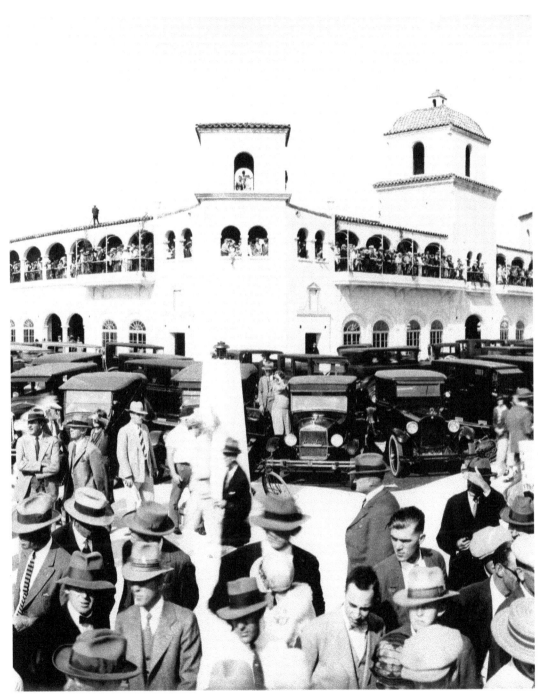

The "Million Dollar Pier" opened Thanksgiving Day, November 25, 1926, with a gala celebration attended by Mayor Pearce, Senator Park Trammel, and ten thousand visitors. At the pier head, the Mediterranean Revival–style Casino included a central atrium, an open-air ballroom, a radio studio for WSUN, and an observation deck.

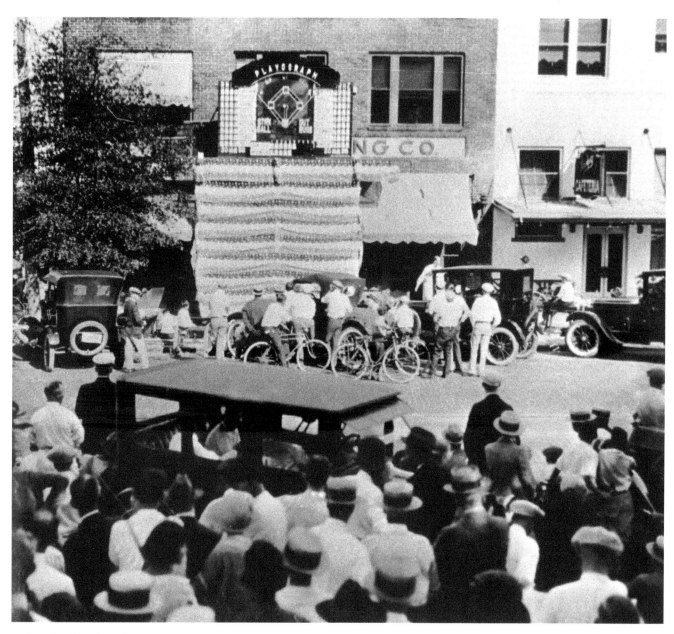

Before play-by-play radio broadcasts of baseball games, various devices like this "playograph" kept fans informed about a game. In front of the St. Petersburg Times building, fans catch up on the latest news, updated by telegraph, about the 1924 World Series. The Washington Senators beat the New York Giants in seven games.

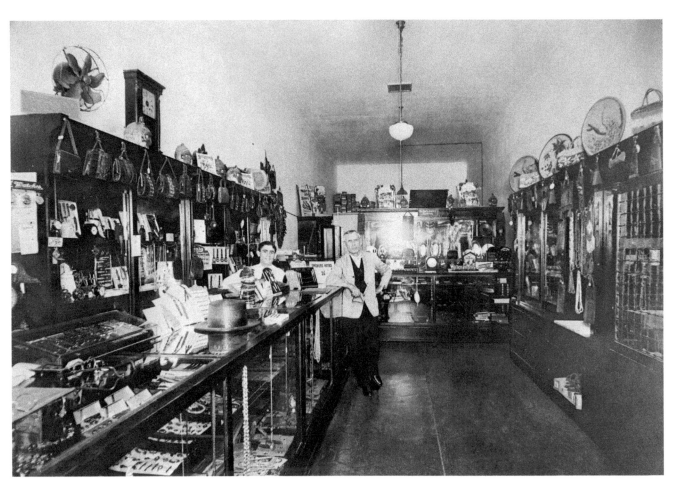

Leon Haliczer at his jewelry store, located at Central Avenue and 9th Street, in 1924. Haliczer was one of the founding members of Congregation B'nai Israel in 1923. As the Jewish community grew, anti-Semitism also grew, manifested in social restrictions that included many of the area's new upscale hotels.

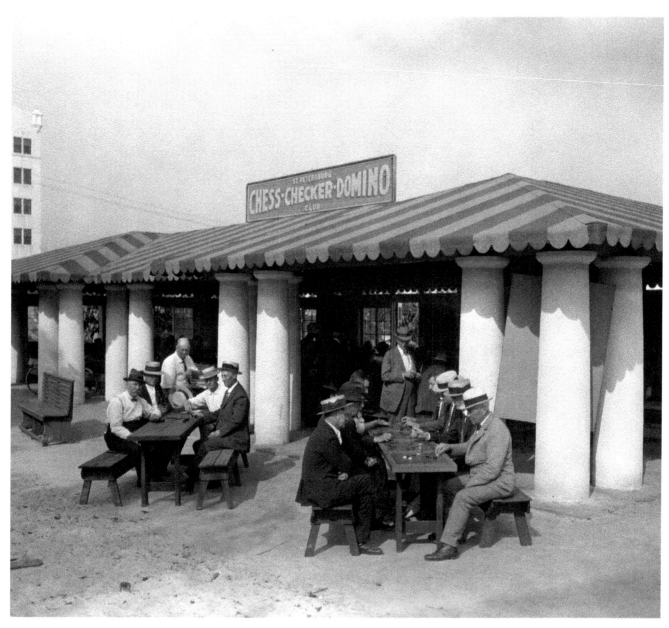

Many sports clubs moved to Waterfront Park, where they had room to expand. The Chess-Checker-Domino Club in Waterfront Park was photographed March 13, 1925. St. Petersburg promoters often held competitions billed as the "National" or "World Championships" of various "tourist sports," including shuffleboard, horseshoes, quoits, and roque.

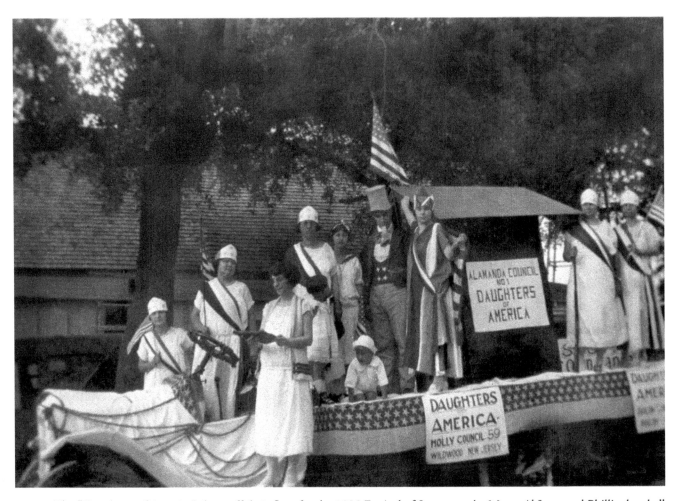

The "Daughters of America" show off their float for the 1925 Festival of States parade. Mayor Al Lang and Phillies baseball scout William Neal designed the parade in 1917 as a tourist attraction based on the many State societies organized in early St. Petersburg. Reinstated in 1922, the parade is a St. Petersburg institution.

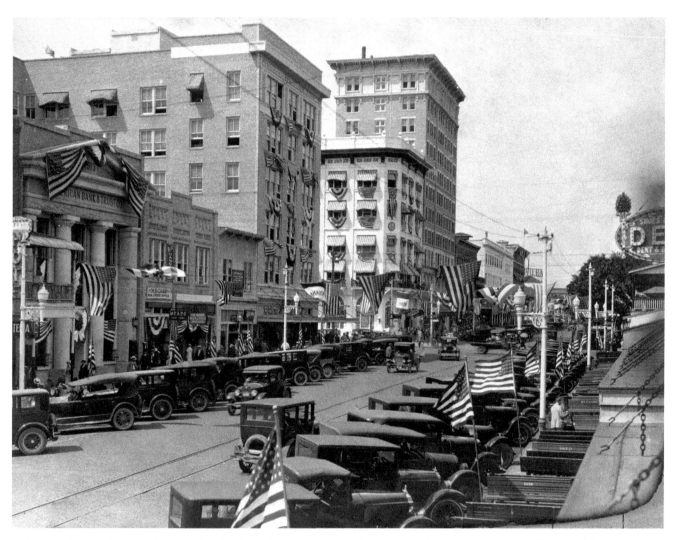

A decorated Central Avenue is ready for a Festival of States parade in the 1920s. This annual event is an offshoot of the State tourist societies. Joining a state society "for one little dollar bill" entitled members to enjoy beach trips, picnics, dances, concerts, musicals, and socials—all with people from their home state.

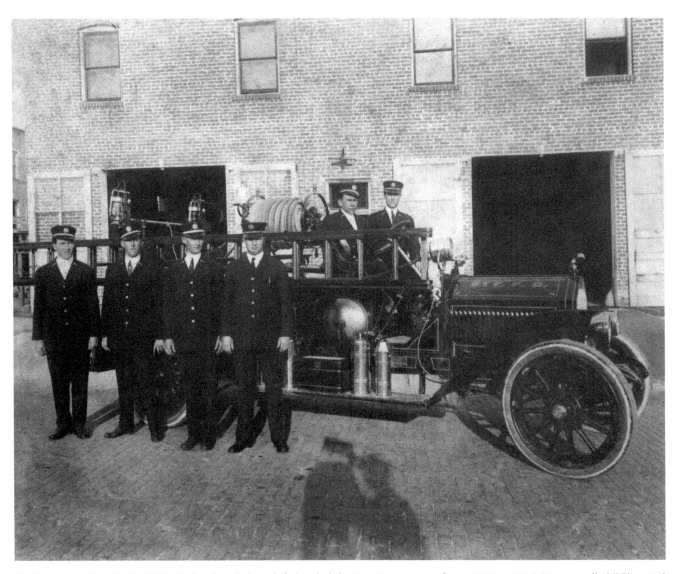

St. Petersburg fire chief J. T. McNulty, fourth from left, headed the Fire Department from 1913 to 1936. He was called "Chemical Crank," because he used chemicals instead of water where possible, to prevent water damage. In 1918, he obtained the city's first modern fire truck, featuring a hose, ladders, and a chemical tank. This photograph is from 1925.

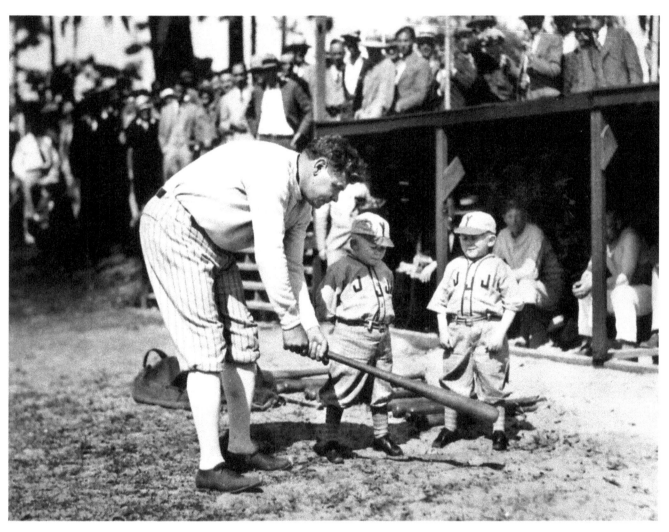

The legendary Babe Ruth demonstrates his grip to batboys Mike and Ike. The New York Yankees moved their spring training camp to St. Petersburg in 1925. To accommodate the Yankees, the city built a new ball park and clubhouse at Crescent Lake Park. Many Yankee players stayed at the Don CeSar Hotel; Ruth preferred the Vinoy.

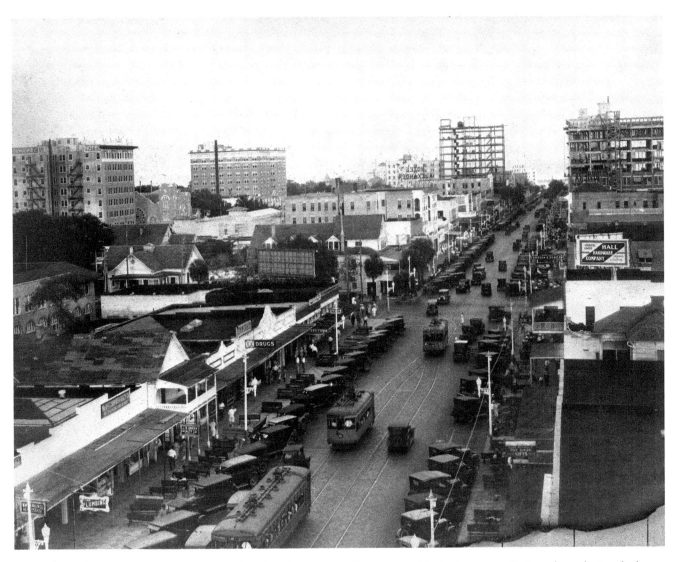

Owing to the tremendous increase in tourism, hotels seem to spring up overnight in downtown St. Petersburg during the boom era. In this view east on Central Avenue is the Suwannee, far left, opened in December 1923; the Mason, under construction in the center, renamed the Princess Martha in 1926; and the Pheil Hotel, far right, finished in 1924.

In 1926, this was the view south on 5th Street from the Suwanee Hotel. The first intersection is Central Avenue and to the right is the famous La Plaza Theatre. As the boom progressed, real estate values soared. One woman wanted to sell her land for $10,000 in 1921, but she was advised to wait. She did and sold the property for $200,000 in 1925.

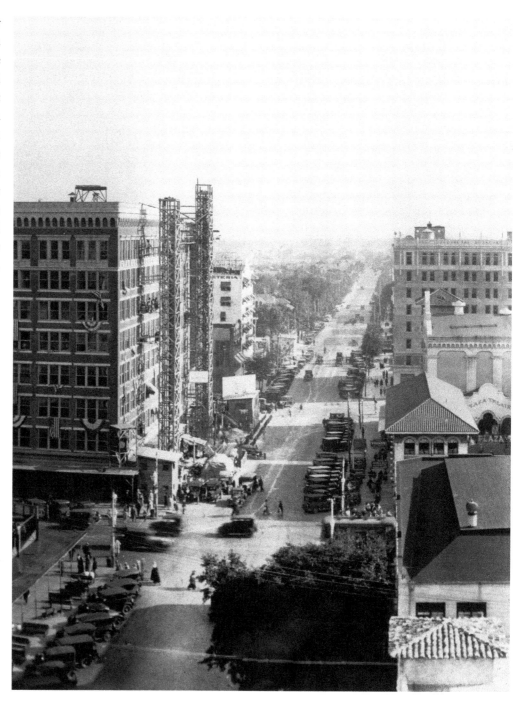

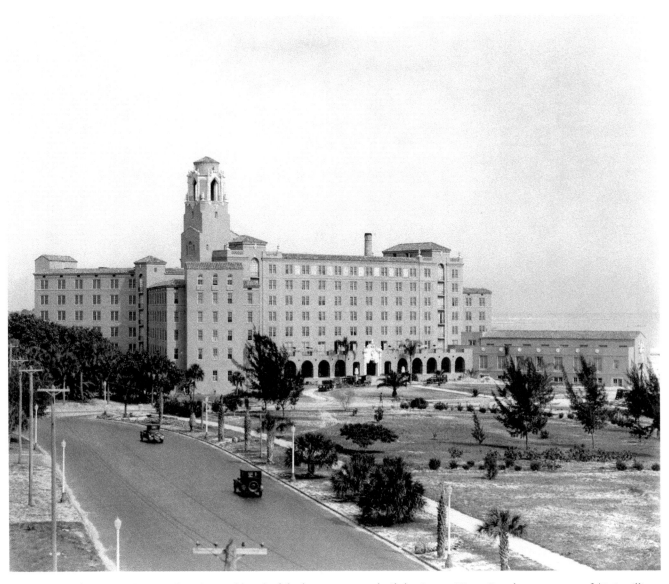

The Vinoy, St. Petersburg's grand hotel of the boom era, was built by Aymer Vinoy Laughner at a cost of $3.5 million. Constructed on the waterfront in 1925, the hotel sat on 12 acres, created with fill from dredging the North Yacht Basin. Designed by Henry L. Taylor, the Mediterranean Revival–style hotel even boasted an observation tower.

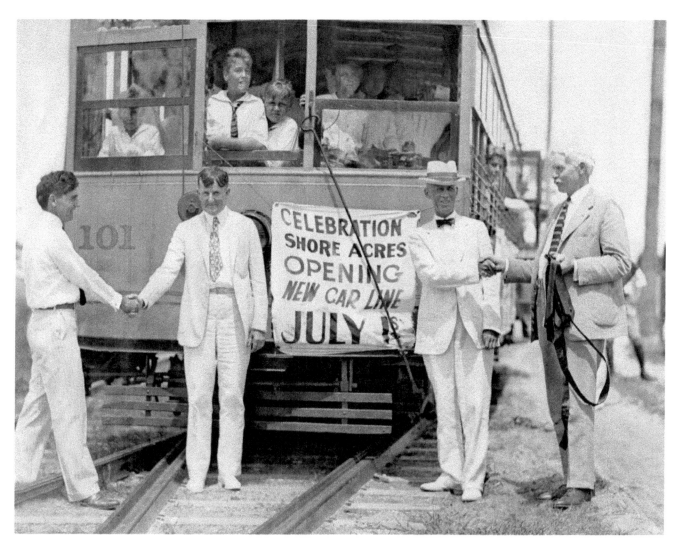

A trolley line opens to Shore Acres in 1926. Developed by Nathaniel J. Upham, twice president of the National Association of Realtors, it was originally pine woods, marsh, and palmetto. A long and expensive drainage project added new land. According to local legend, Al Capone purchased a home there that same year.

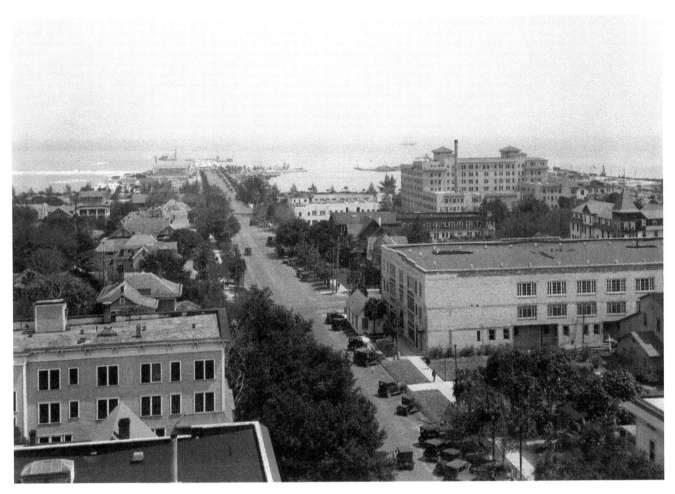

The Soreno Hotel (right, rear) was billed as the first million-dollar hotel in St. Petersburg and opened on New Year's Day 1924. The 300-room waterfront hotel was owned by Soren Lund, a Danish immigrant. During World War II, it became a training base for cooks and bakers. Its demolition was filmed in 1992 and added to the movie *Lethal Weapon III*.

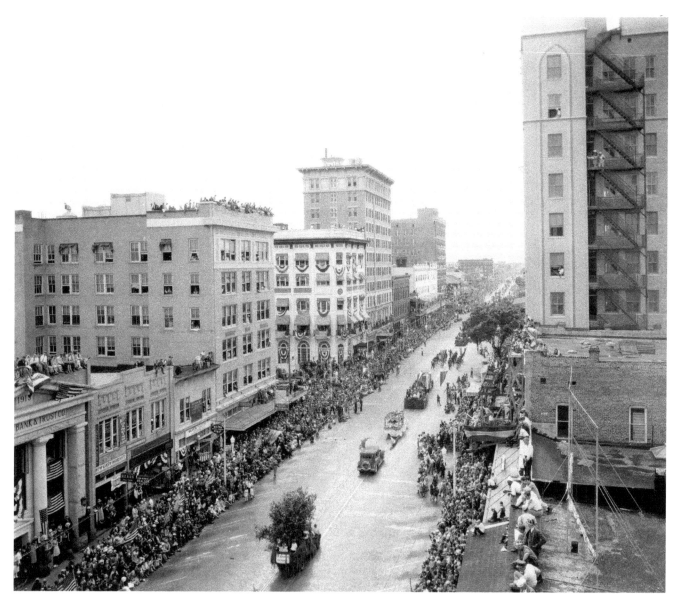

Central Avenue's one-hundred-foot-wide streets easily accommodate this large crowd at the 1926 Festival of States Parade. Spectators also line the buildings, porches, rooftops, parapets, overhangs, and windows. This bird's-eye view faces west toward the 13-story Phiel Hotel and theater.

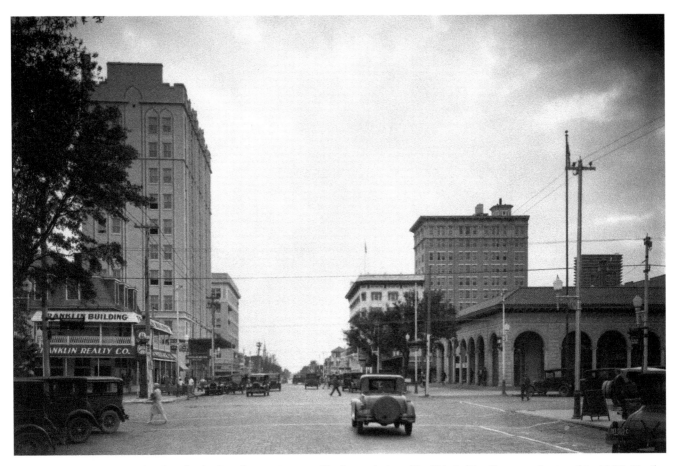

A unique community landmark, the first "open air post office" was designed by Edwin Tomlinson and opened in 1907. Similar plans for a new structure were scoffed at by the postal service, but Postmaster Roy Hanna insisted that the open-air design was well suited for St. Petersburg and in 1917 the second Open Air Post Office, shown here at right, was dedicated.

This image shows the Snell Arcade soon after its 1926 completion. Offered $1 million for this northwest corner of Fourth and Central, real estate developer C. Perry Snell instead spent $750,000 building the landmark structure. He soon lost it in a foreclosure to an insurance company. Designed by Richard Kiehnel, this architectural landmark featured a terra-cotta exterior, bas-relief details, and an ornate parapet. During a revitalization project in the 1980s, columns, arches, and other unique architectural details were rediscovered, including a seventeenth-century mosaic hidden from view since the 1950s, when the arcade was modernized.

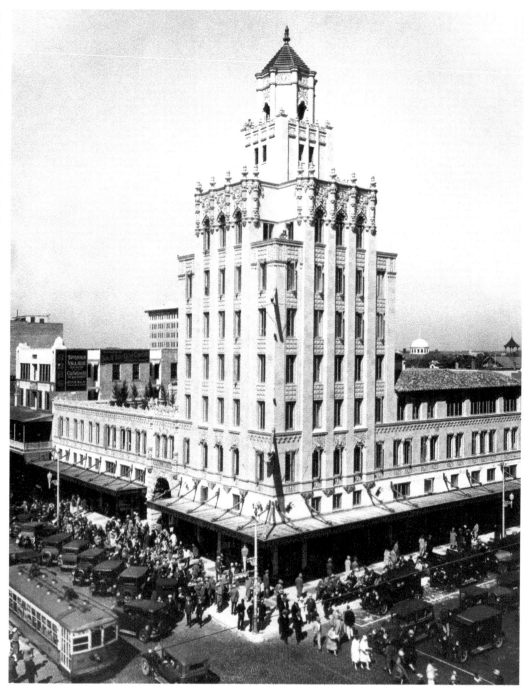

Overcast: Bust and Depression Years

(1927–1940)

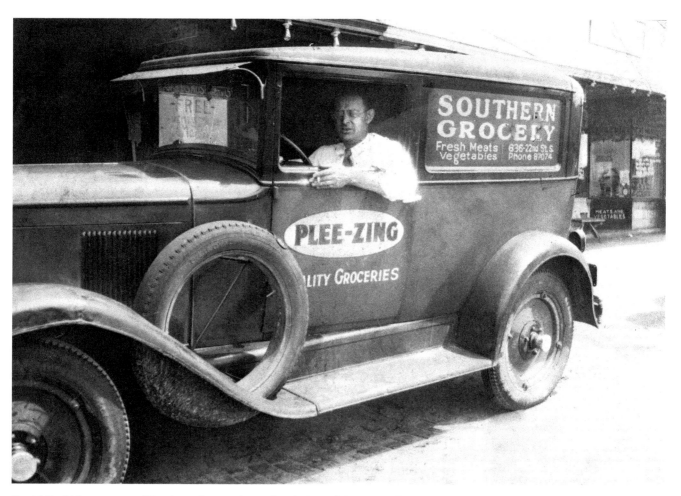

David Rothblatt, owner of Southern Grocery located at 636 22nd Street South, poses for a photograph in his delivery truck. Isaac Jacobs, who had moved from Chicago and opened the store, invited his daughter, Ethel, and her husband, David Rothblatt, to join him in the family business. The couple came to St. Petersburg from Milwaukee.

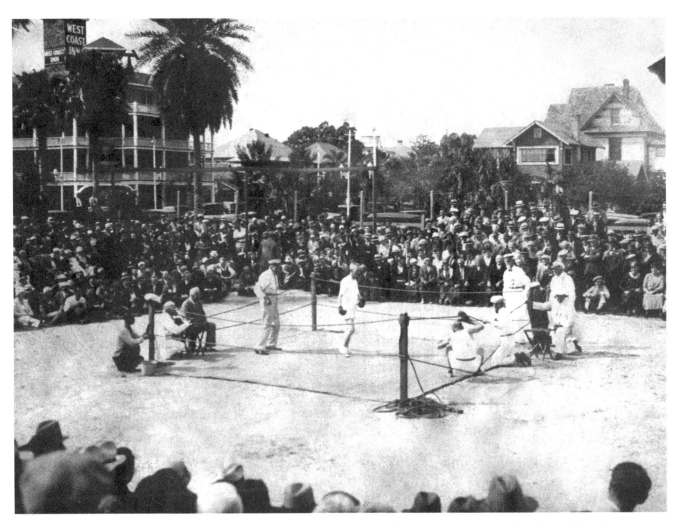

With the advent of the 1930s and the national economic downturn, St. Petersburg was promoted as "the perfect place to sit out the depression." There were always activities for retirees, even boxing matches. This one is taking place in front of the West Coast Inn, with its distinctive shingled tower and wraparound verandas.

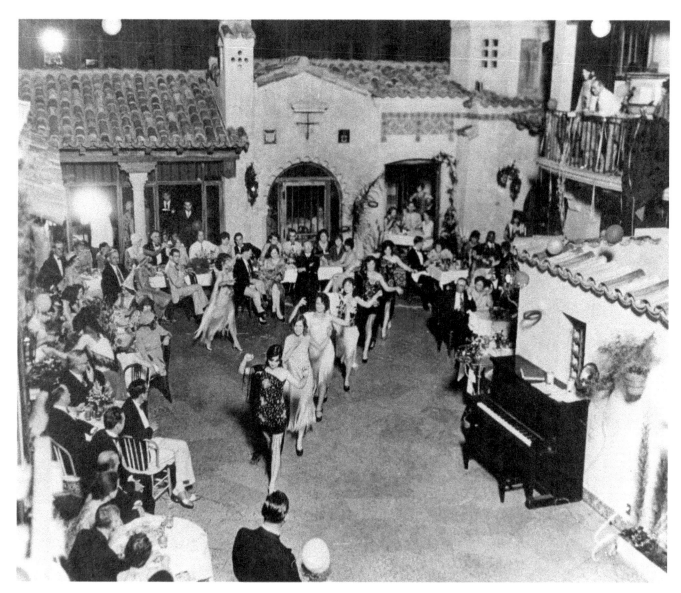

An audience watches the dancers at Spanish Bob's nightclub on the third-floor terrace of the Snell Arcade. Bob's was a popular hot spot and a favorite of Babe Ruth's. In 1937, Walgreen and Company purchased the arcade for $500,000, adding $100,000 in remodeling.

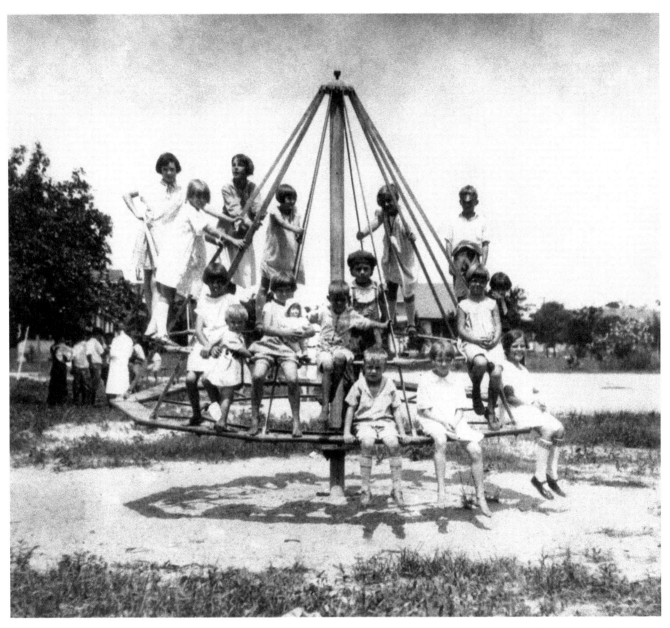

Children continued to have fun at this playground, but elsewhere in 1930, St. Petersburg like the rest of the nation was feeling the effects of the Great Depression. There were local attempts at relief—a Citizen's Emergency Committee even issued scrip used to pay wages and honored by most area merchants.

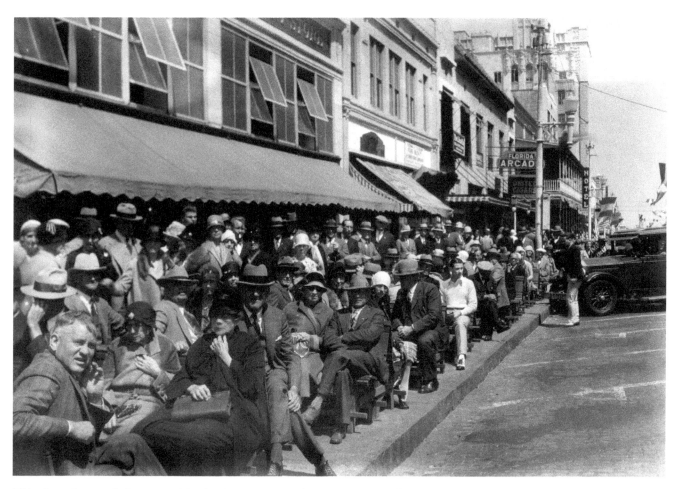

This view of a crowded street on March 26, 1930, inspired someone to note that one "may easily get acquainted and enjoy passing a few hours on these benches." The depression forced many unemployed to join the retirees and tourists on the famous green benches. The few tourists who did come had limited funds and added little to the economy.

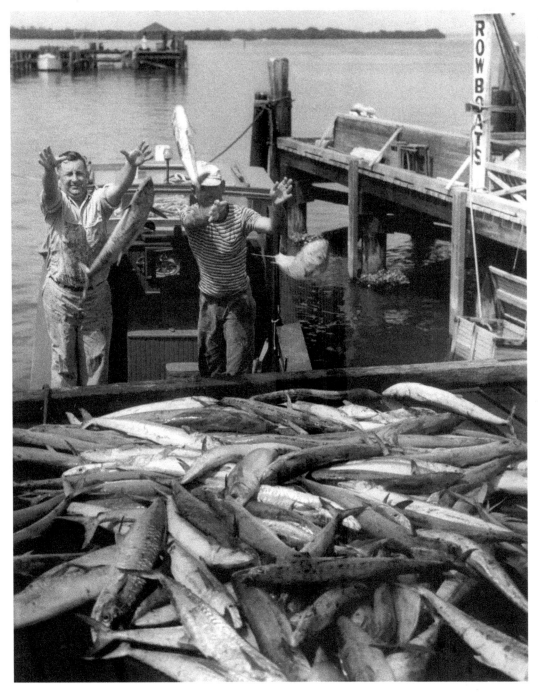

A day's catch at Pass-A-Grille in 1935. Eccentric but wealthy Sir Charles Ross thrilled the Chamber of Commerce with his testimonial: "I have fished everywhere, but I have never caught a greater variety of fish than I have at Pass-A-Grille. This season I have caught over 10,000 pounds of fish, and I'm coming back for more."

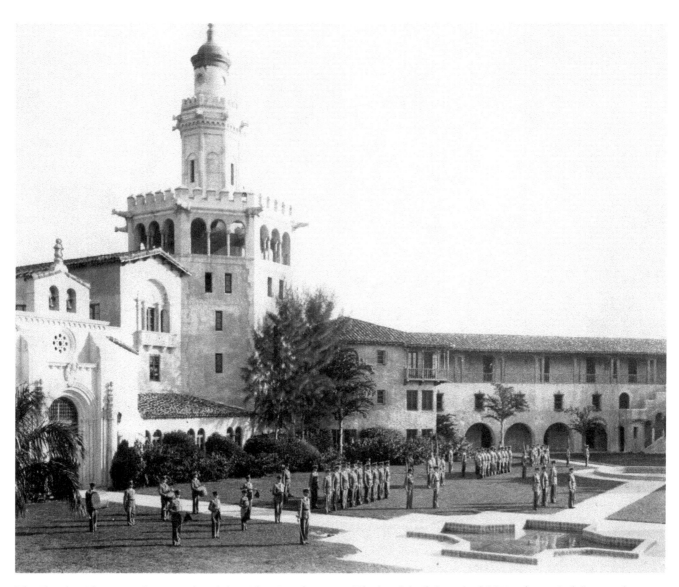

The Florida Military Academy purchased the Rolyat Hotel in 1932. The hotel, built by colorful "Handsome Jack," opened in January 1926. Inspired by Spain's feudal period, it featured a courtyard with a well and two large fountains, two towers, and an elaborate main entrance. ("Rolyat" is Taylor spelled backward.) This view is from 1939.

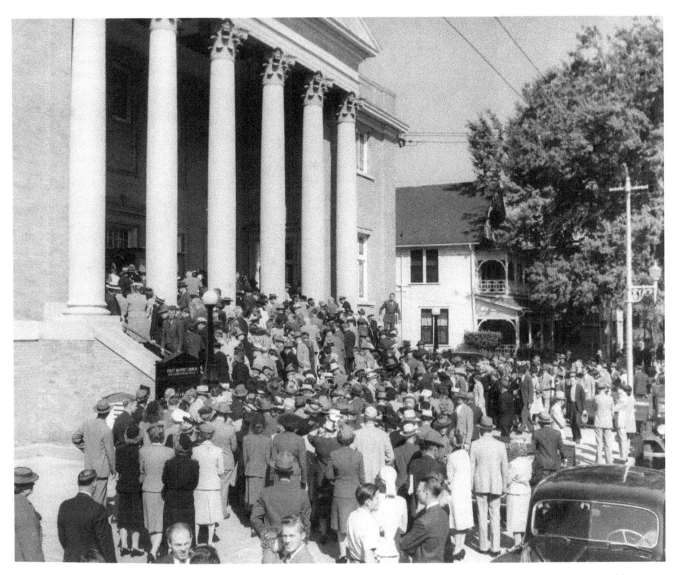

A crowd enters First Baptist Church in 1935 for services. The congregation was organized in 1892, and moved to several locations before buying a lot on Fourth Street North opposite Williams Park. This Neoclassical-style building, erected in 1923, is one of only 28 buildings of this style remaining in St. Petersburg.

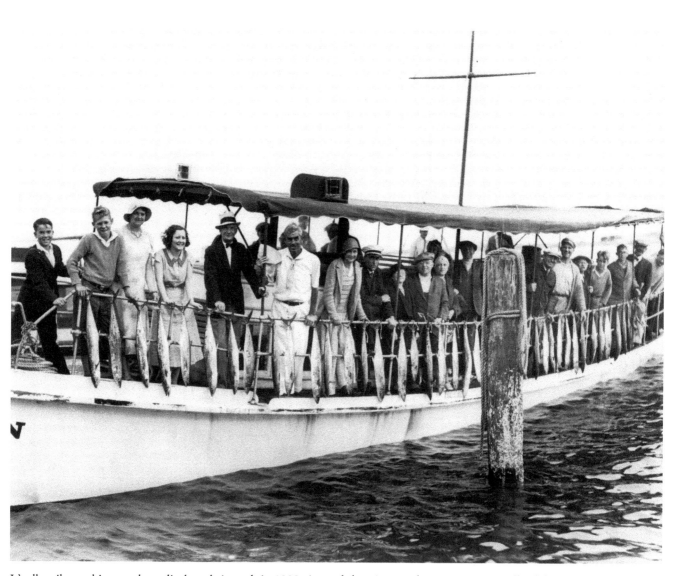

It's all smiles as this party boat displays their catch in 1938. Around that time, as the story goes, a mullet fisherman got more than he bargained for when mullet started jumping out of his nets into his little dory and it started sinking. A witness to the event, J. W. Prichard recalled, "I'll never forget the look on his face when he found himself neck-deep and going deeper."

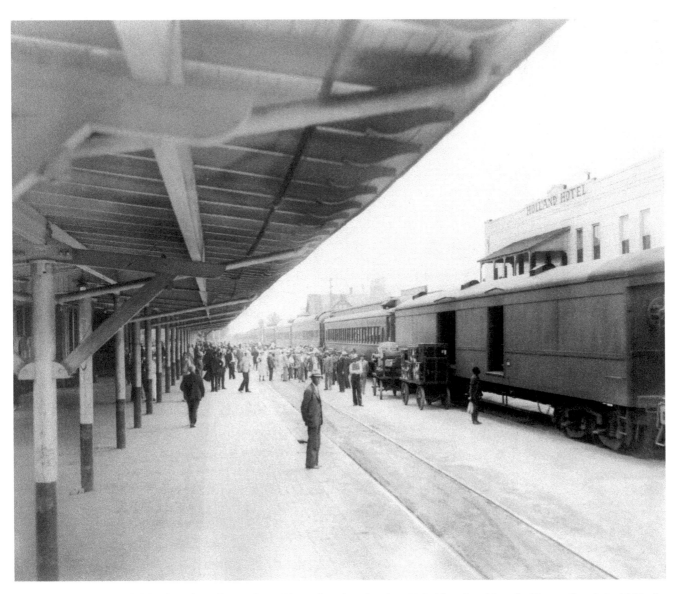

Passengers meet and debark at the Atlantic Coast Line railroad station in 1936. After absorbing the Plant railroads in 1902, the ACL spent $5 million to upgrade service. The first through-train from New York to St. Petersburg arrived in 1909, and in 1915 a $100,000 passenger depot was completed on First Avenue South.

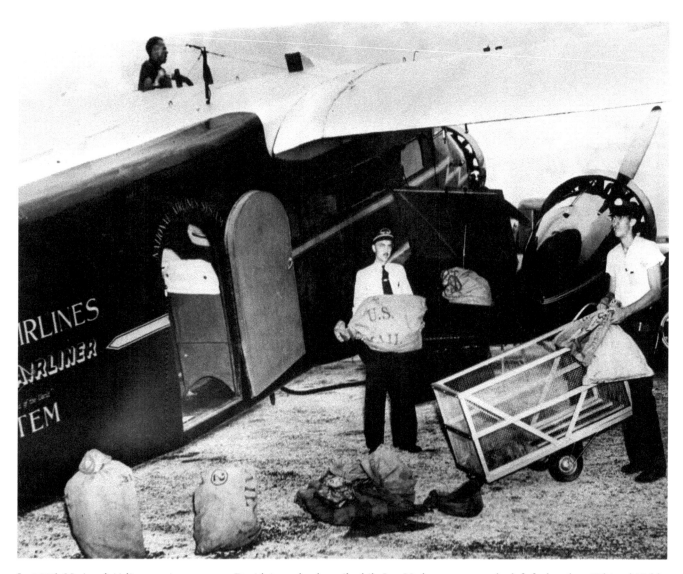

In 1936, National Airlines station manager David Amos loads mail while Lee Hederman gasses the left fuel tank at Whitted Field. This Stinson Trimotor, labeled a "Giant of an Airplane" by the *St. Petersburg Times,* held eight passengers and a crew of three. G. E. "Ted" Baker started National in 1934 with two aircraft and five employees.

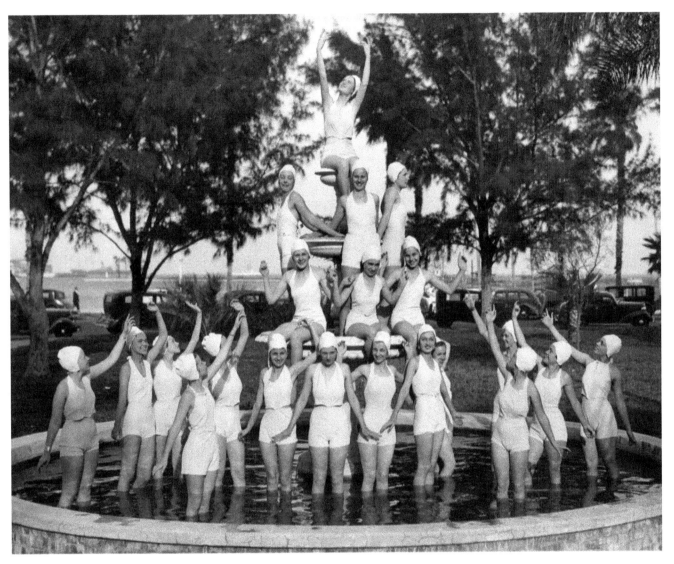

A 1936 publicity shot of young ladies in bathing suits. Publicity agent John Lodwick masterfully promoted St. Petersburg for 23 years. In one stunt, Lodwick had Mayor Frank Pulver battle a fictitious Purity league that demanded a bathing suit inspector to ensure that women's bathing suits covered at least half their body.

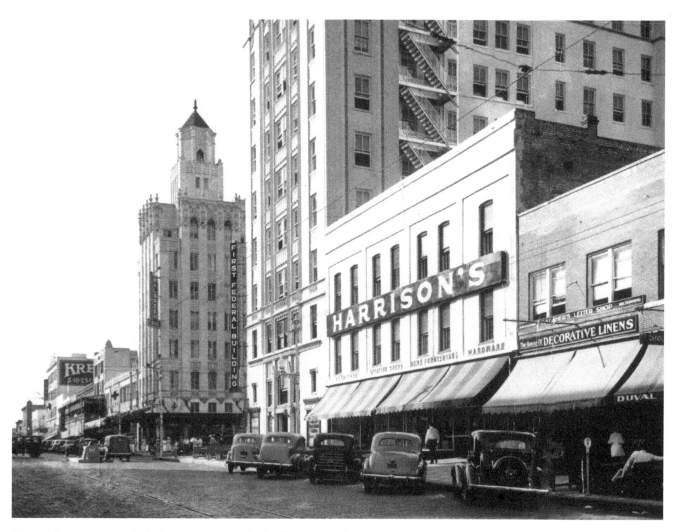

Central Avenue seems relatively quiet in 1938, flanked by Harrison's Hardware, the Snell Arcade, and the First Federal Building. Early residents Edgar Harrison and his two sons started a general store in a small, 25-foot by 50-foot area. In 1907, they built Harrison's hardware and furniture store in the town's first large, brick building.

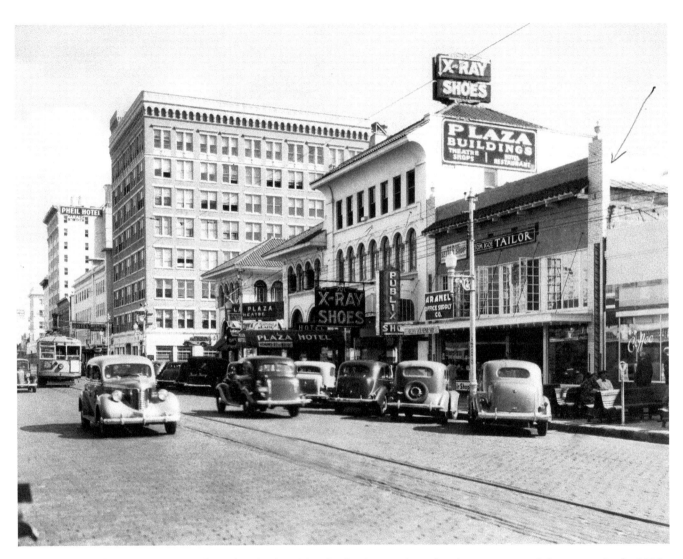

The Plaza buildings in 1938 are adorned with advertising for the theater, shops, hotel, restaurant, and shoe stores. In the 1930s, many of the leading shoe stores had X-ray shoe-fitting machines that used an X-ray tube to produce an image of the feet within the shoes. Many states eventually banned them owing to radiation hazards.

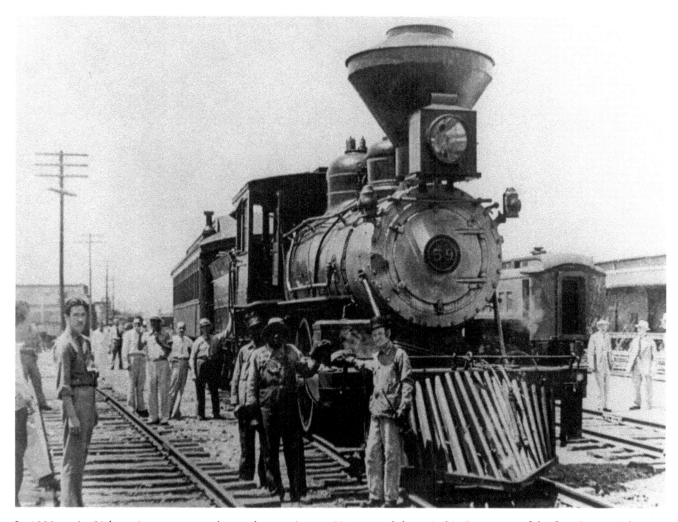

In 1938, on its 50th anniversary, restored steam locomotive no. 59 reenacted the arrival in June 1888 of the first Orange Belt Railway train. Originally the locomotives of the Orange Belt were second-hand narrow-gauge engines and represented many different builders—Baldwin, National, and Pittsburgh.

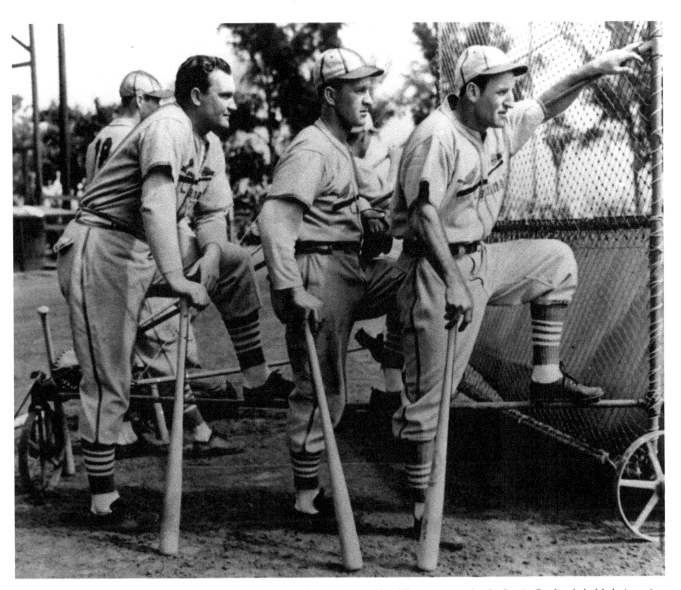

In 1937, the Boston Braves moved to another location after 16 years. The following year the St. Louis Cardinals held their spring training in town. Player-manager Frankie Frisch and the gas-house gang were one of the best teams of the 1930s, winning two World Series titles and enjoying four second-place National League finishes.

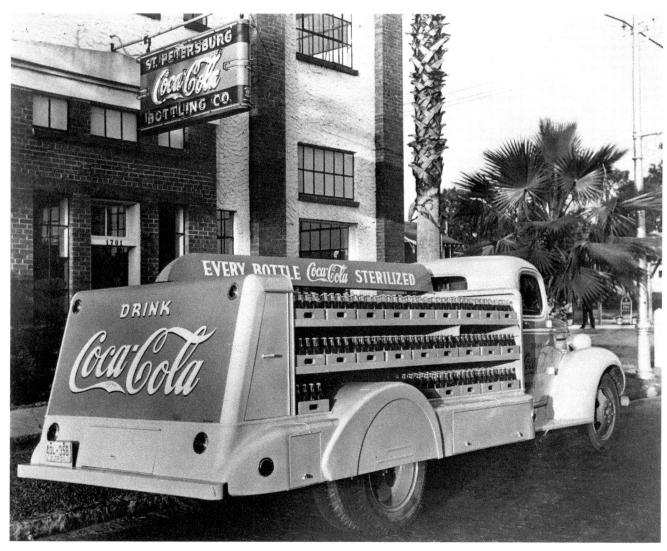

A Coca-Cola truck appears ready to start its delivery runs outside the old bottling company building. In 1940, the St. Petersburg Bottling Company relocated to the American Legion Armory and had it completely remodeled. In 1967, the Turner family acquired that building and added it to Sunken Gardens as a gift shop.

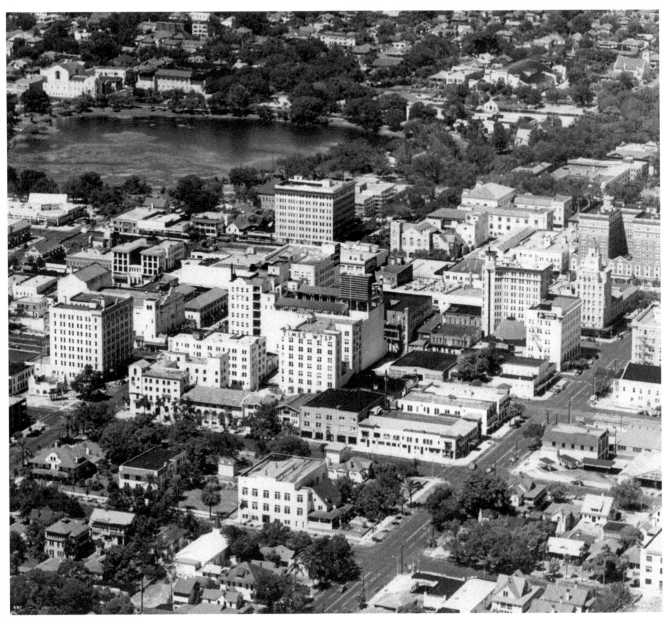

This 1939 aerial view of downtown features Mirror Lake toward the north. Despite the Great Depression, the city continued to grow—during the decade the population increased by approximately 50 percent, to 60,812. The Snell Arcade, center-right, is at the city's main intersection of Central Avenue and Fourth Street.

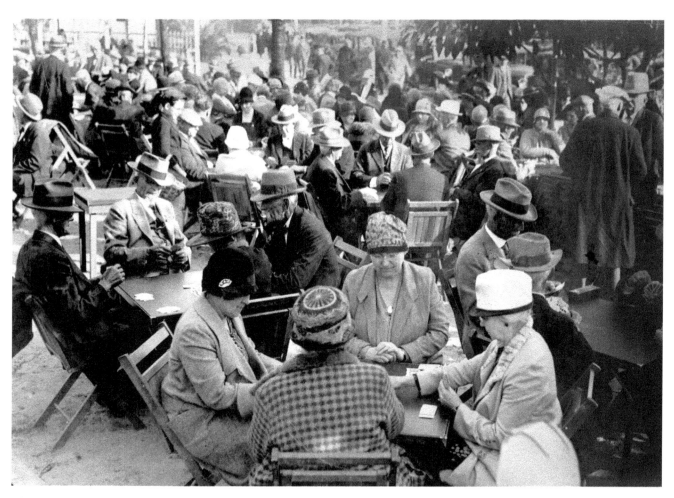

This card tournament at Mirror Lake Park was a welcome economic signal. Tourism was picking up by the 1940s and it was becoming common again to see hundreds of cardplayers around tables in the parks enjoying bridge and other card games. According to one promotional tract, "Bridge players come from every state in the Union."

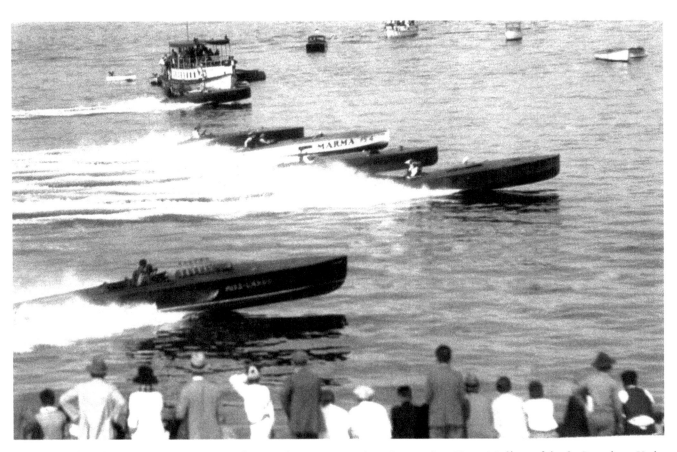

The Southland Sweepstakes Regatta gained national prominence when Commodore Harry M. Shaw of the St. Petersburg Yacht Club selected the race as a principal activity of the Yacht Club's Winter program. Starting in the winter of 1939-40 and originally held in the bay off the pier, the races were moved to the smoother waters of Lake Maggiore.

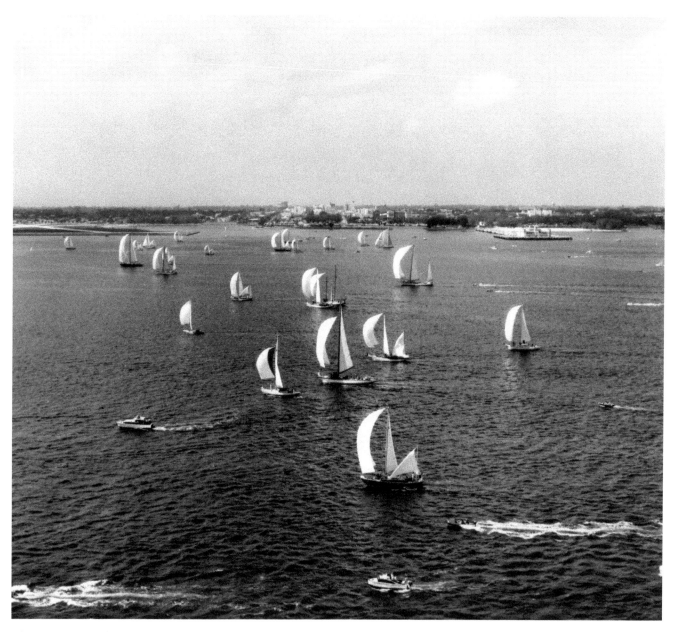

The 1940 start of the St. Petersburg to Havana, Cuba, sailboat race, sponsored by the St. Petersburg Yacht Club. There were sailboat classes for the 284-mile course: boats under 50 feet in length and those between 50 and 85 feet. Eleven boats participated in the first event. Held annually in March, the races ended in 1959.

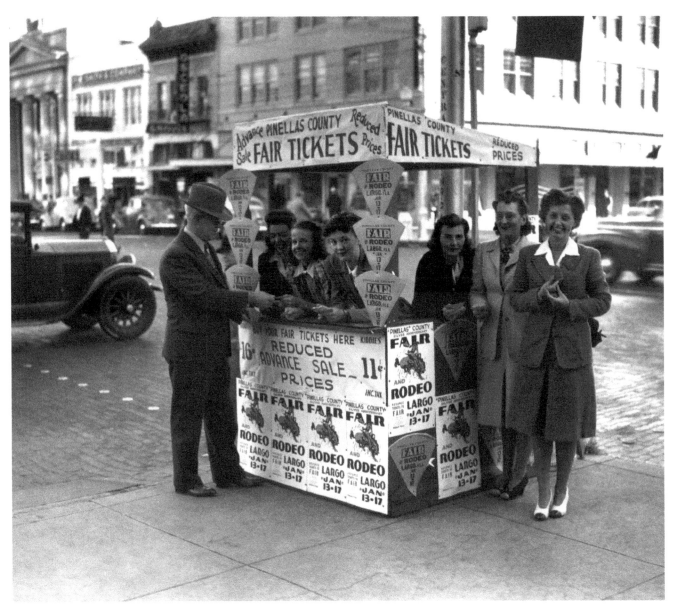

The Women's Club of Largo held the first county fair January 25-27, 1917, aimed at showing the county's resources to the winter tourist and visitor. Low on finances, the first agricultural building was made from lumber scraps and palmetto leaves. Owing to its success, the Pinellas county fair was transferred to the county in 1925. Shown here is a ticket booth for the 1940 fair.

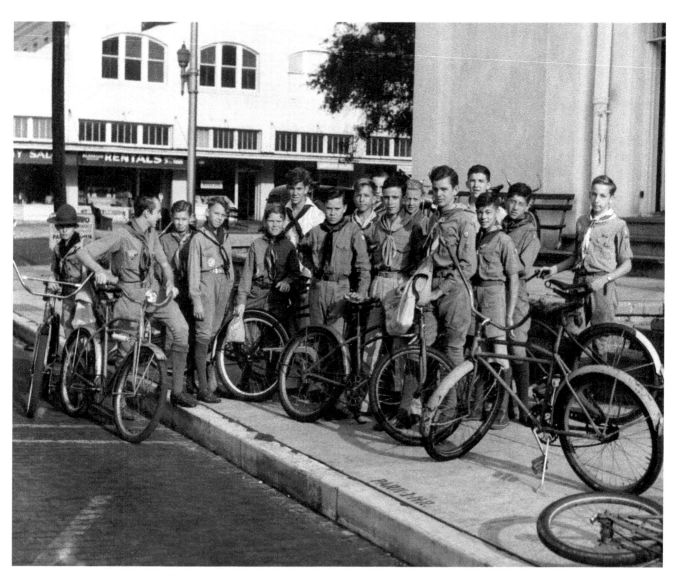

The first Boy Scout troop in St. Petersburg was organized by a woman, the remarkable Katherine Tippets. The first Scout Master of the Pinellas Boy Scouts was developer Walter P. Fuller. The first St. Petersburg recipient of the Distinguished Eagle Scout Award was William R. Hough, who may be part of this 1940 troop.

Clearing Skies
World War II and Postwar Boom

(1941–1960s)

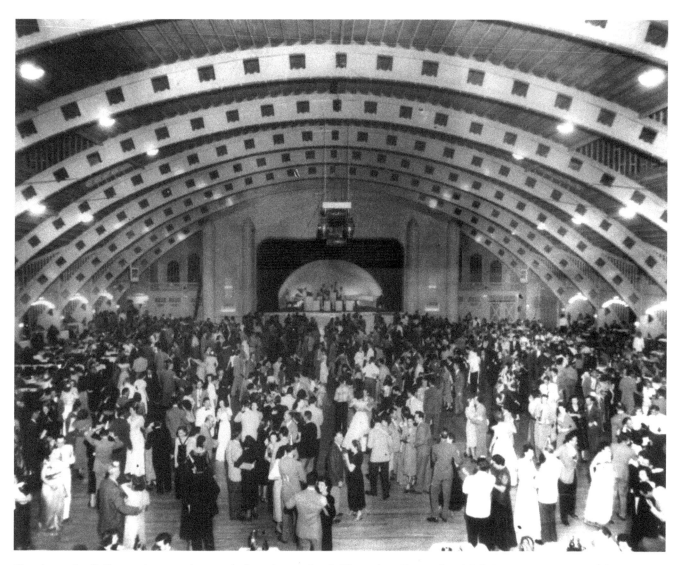

Couples at the Coliseum dance to the sound of a swing-era band. The unique Rotary Jewel lighting system comprised four cone-shaped cylinders fastened together to form a square, each cone covered with mirrors. Electrically operated, the "Jewel" revolved slowly for moonlight dances.

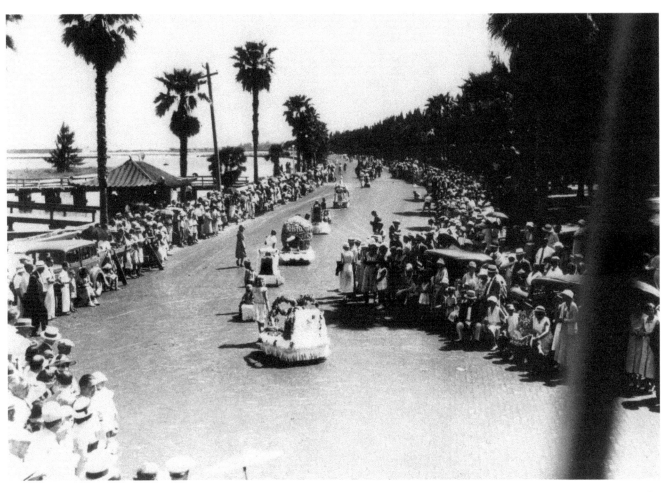

The Festival of States parade was curtailed during the first years of the Great Depression. By 1935, as tourists began returning, the annual parade gradually became more elaborate. The event reached a pinnacle in 1938, the 50th anniversary Golden Jubilee of the founding of St. Petersburg. In view here is the festival for 1941.

Young women wait in line for volunteer registration. All of St. Petersburg joined the war effort, but maintaining the home front fell to young and middle-aged women. They worked as nurses with the Red Cross, teachers, clerical staff, trolley operators, and at many other roles ordinarily filled by men, who were overseas engaging the enemy.

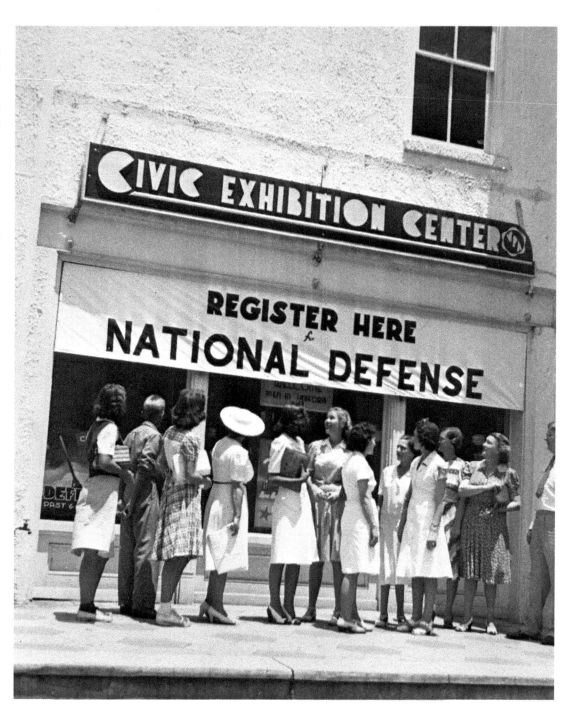

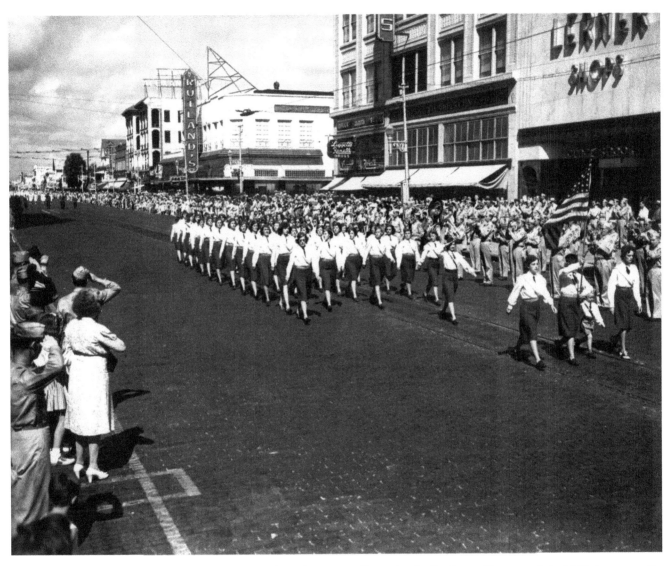

The honor guard of this Women's Army Auxiliary Corps proudly carries the flag in a military parade in 1942 downtown St. Petersburg. Converted later into the Women's Army Corps, the corps involved many women from St. Petersburg. The WACs were the first women other than nurses to serve in the United States Army.

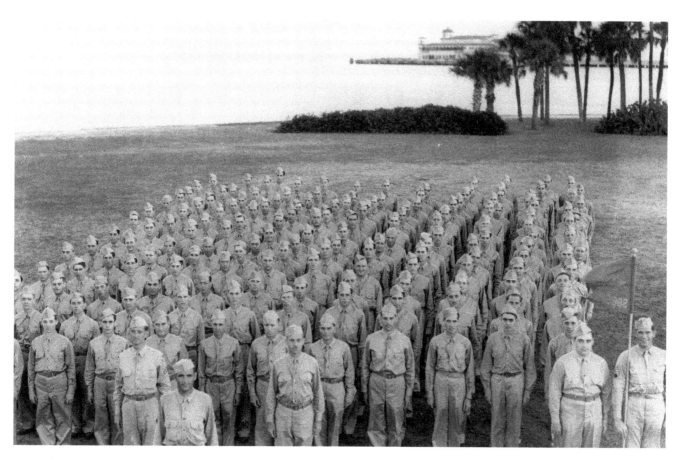

Formerly catering to tourists, the town's hotels now provided living quarters for Army Air Corps trainees, like this unit near Vinoy Park. In 1942, the town was selected as a basic training camp for the Army Air Corps Technical Services. More than 100,000 servicemen had trained at the center by the time it closed in July 1943.

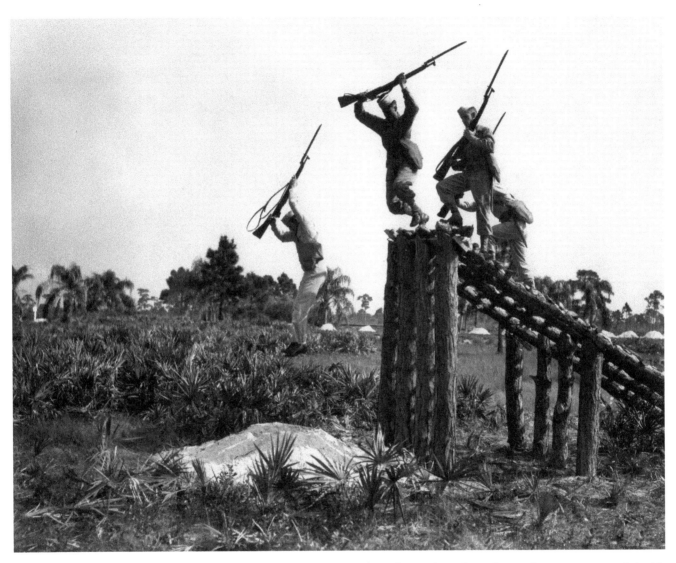

Soldiers work their way through an obstacle course near St. Petersburg. Throughout the war the town was crowded with servicemen from all over Florida on furlough, creating a boom in the local economy. Visiting wives and families relocated to St. Petersburg to be near their servicemen, many families staying after the war.

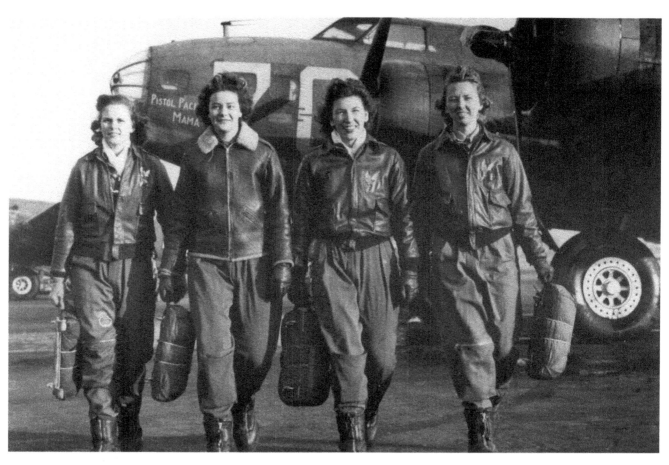

These Women's Air Force Service pilots served the war effort by ferrying bombers between military bases. The Tampa and St. Petersburg areas were vital sites for the training of Army pilots. Many service personnel visited or relocated to St. Petersburg, increasing the population from 60,000 to 85,000 by 1945.

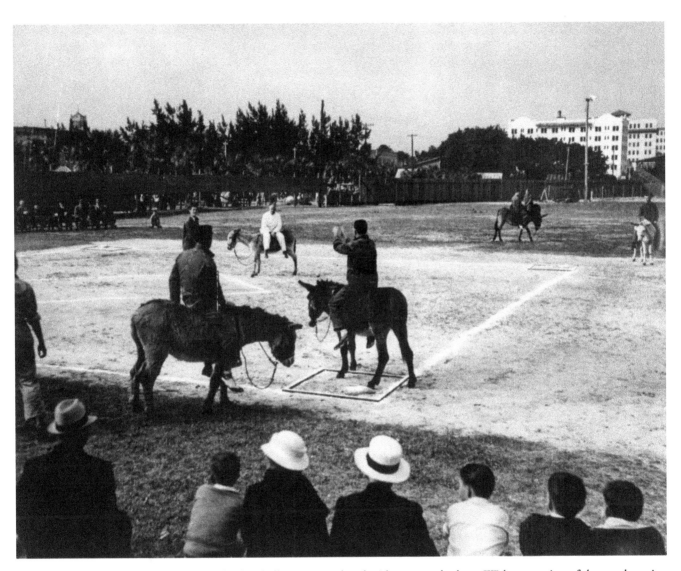

On a field near the West Coast Inn, this baseball game was played with men on donkeys. With suspension of the usual tourist-oriented activities, the city provided numerous activities for servicemen. From 1943 to 1945, there were no Festival of States parades, no yacht races, and no spring-training camps.

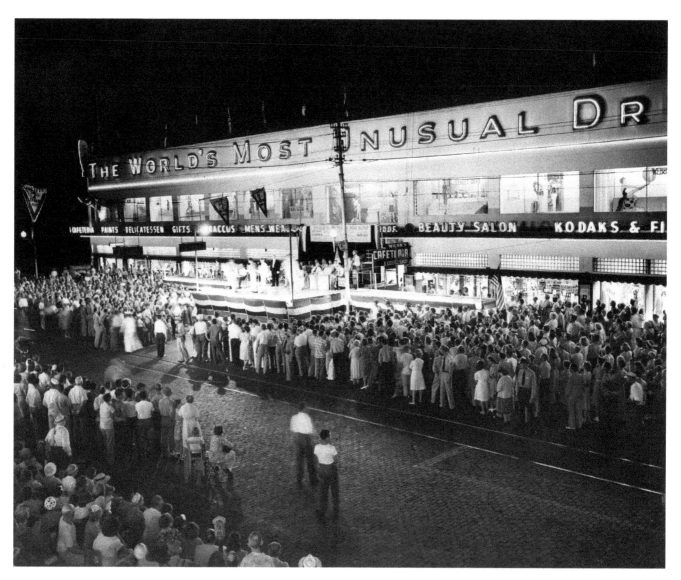

A war bond drive is held on a night in 1942 at Doc Webb's "Most Unusual Drug Store." James Earl "Doc" Webb, known as the master showman of volume sales, bought a small drugstore and through the 1930s, by concentrating on volume sales, turned it into a complex of stores known as Webb's City. Its annual sales in 1941 surpassed $4 million.

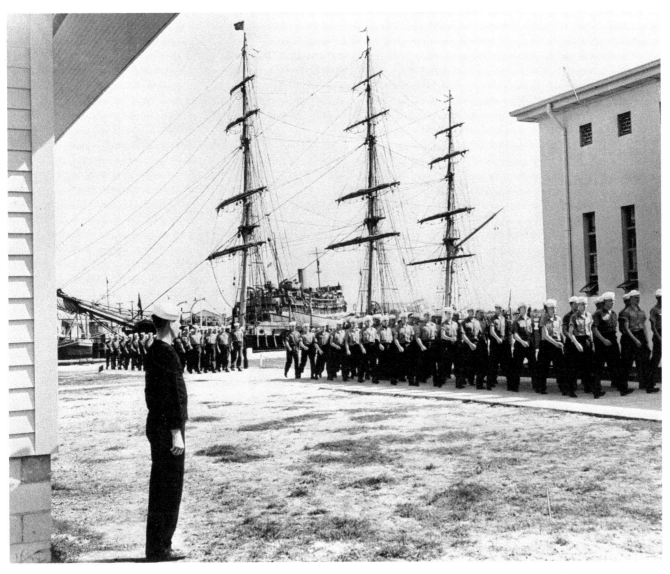

At the beginning of the war, the Coast Guard operated a training facility at Bayboro for merchant seamen, with approximately 250 recruits and two training ships, the *Joseph Conrad* and the *American Seaman*. In 1942, the facility was transferred to the United States Maritime Service, and a large barracks housing 800 men and a classroom building were added.

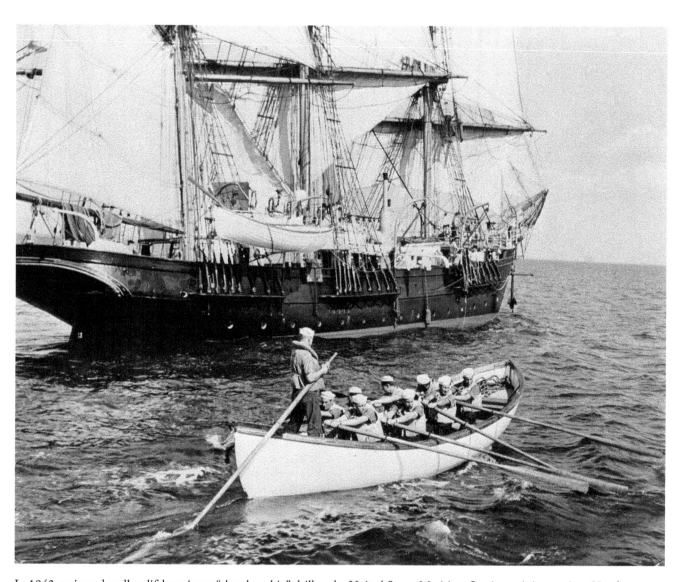

In 1943, trainees handle a lifeboat in an "abandon ship" drill at the United States Maritime Service training station. Hotels and businesses stayed busy as the Maritime Service facility at Bayboro was expanded, training 25 thousand seamen by the end of the war.

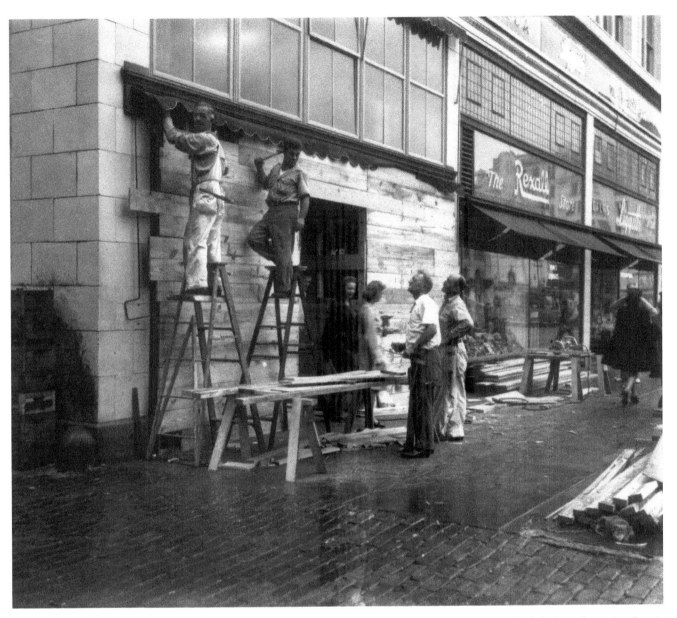

Businesses are boarded up in 1945 as a hurricane threatens the area. An early storm that season had dissipated greatly when it hit Cedar Key on June 24. On September 4, a second tropical storm skirted the west coast of Florida, causing minor damage. A category 4 hurricane hit Miami on September 15 and turned north over the peninsula, resulting in four deaths and millions of dollars in damages.

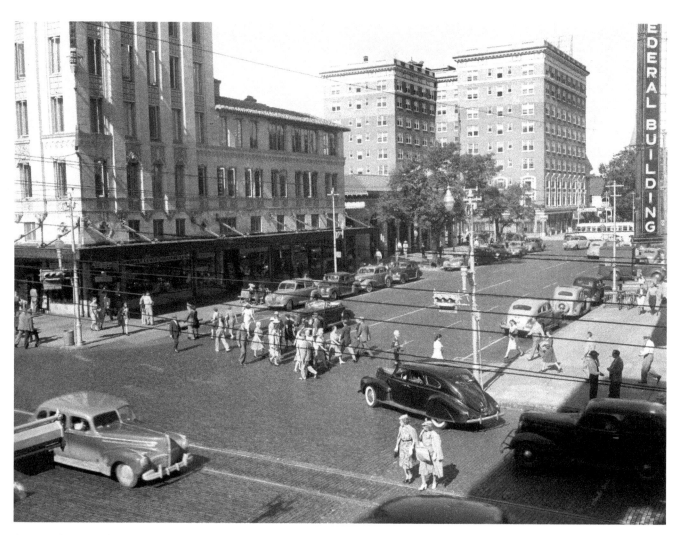

St. Petersburg quickly returned to a civilian footing after the war as newcomers from across the nation relocated. Supplementing this postwar boom was a fund the city had built up from wartime municipal utilities. The city spent the fund, in excess of $1 million, to improve parks, streets, baseball fields, and the waterfront.

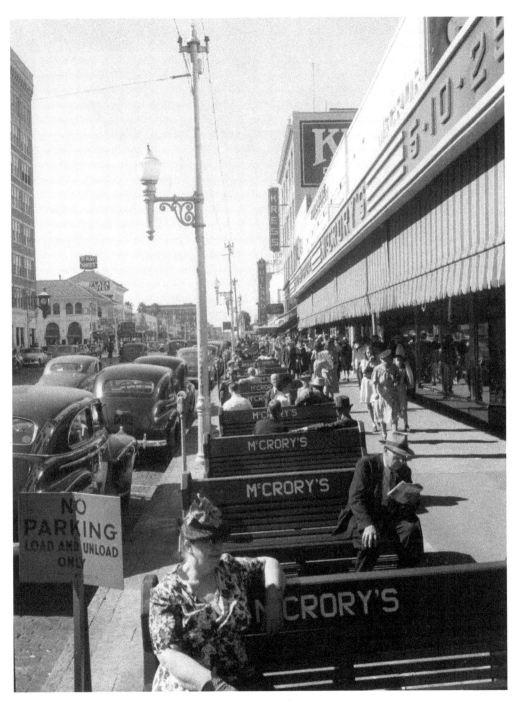

Alongside the familiar green benches, downtown Central Avenue stores are busy with postwar customers here in 1946. On the right, pedestrians stroll past McCrory's, Kress, and Rutland's department store. On the left is the Plaza Theatre, which was demolished in 1957.

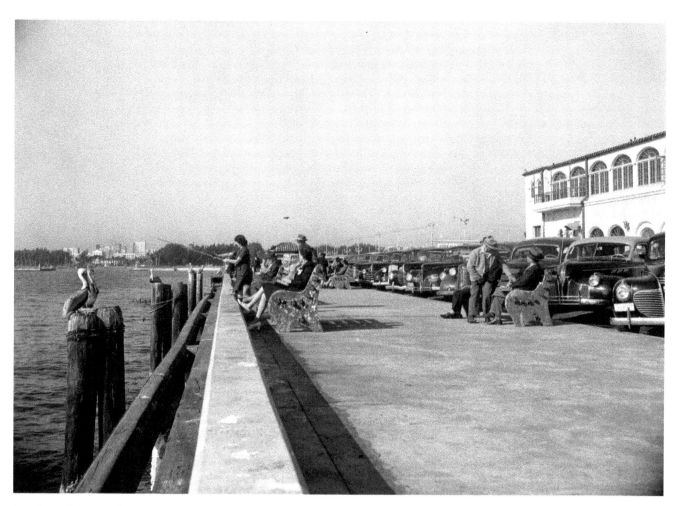

People are fishing and cars are parked along the Million Dollar Pier in 1946. The city had used postwar funds to repair the pier, which remained popular as a gathering place for cardplayers, tourist meetings, community sings, and fishing tournaments. Once again it became a popular fishing spot for mackerel, trout, and redfish.

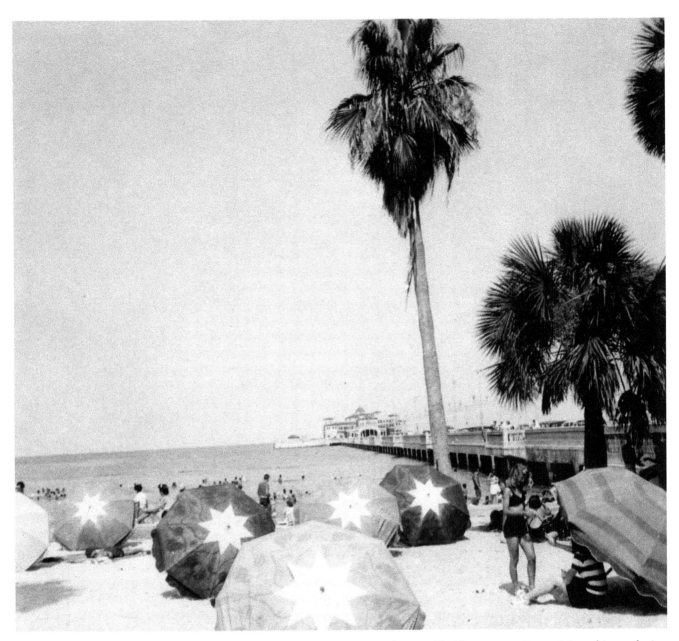

This 1946 publicity image was used as a lure to entice Americans to visit the area. Florida state agencies participated in producing and distributing promotional literature to encourage Florida tourism, an effort that succeeded. In St. Petersburg, the population increased from 85,000 in 1945 to more than 90,000 in two years.

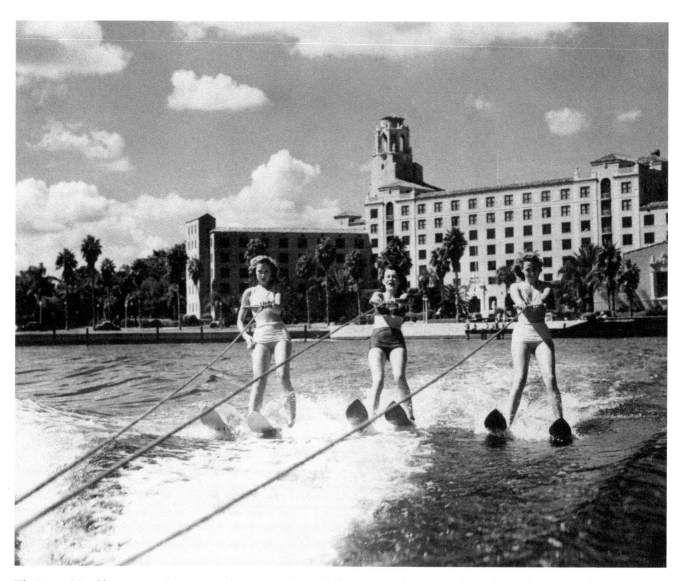

The Vinoy Hotel became a training center for army cooks and bakers during the war. Kitchens that had served lavish meals now served as classrooms, and troops bunked in rooms where millionaires had resided. Briefly closed for repairs, the Vinoy opened again for guests in 1946 and resumed its place as a favored winter destination.

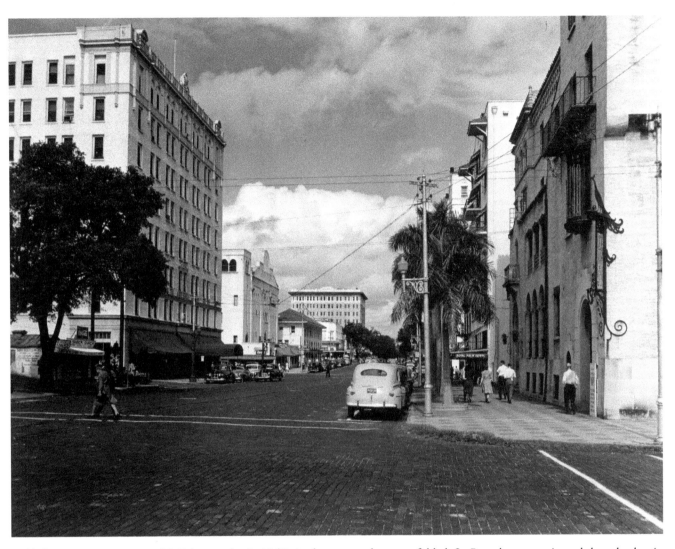

Fifth Street seems empty on this February day in 1947. As the postwar boom unfolded, St. Petersburg experienced the suburbs. As home construction permits rose from just 11 in 1943 to more than 1,500 in 1946, vacant twenties-boom-era subdivisions came to life again, and development throughout the area drew people away from downtown.

A view across Mirror Lake in November 1947. Motivated by the growth of the suburbs, the city government focused on improvements aimed at rejuvenating downtown. The ambitious program included street improvements, a new sewer system, a large city park, Lake Maggiore, and a new athletic park.

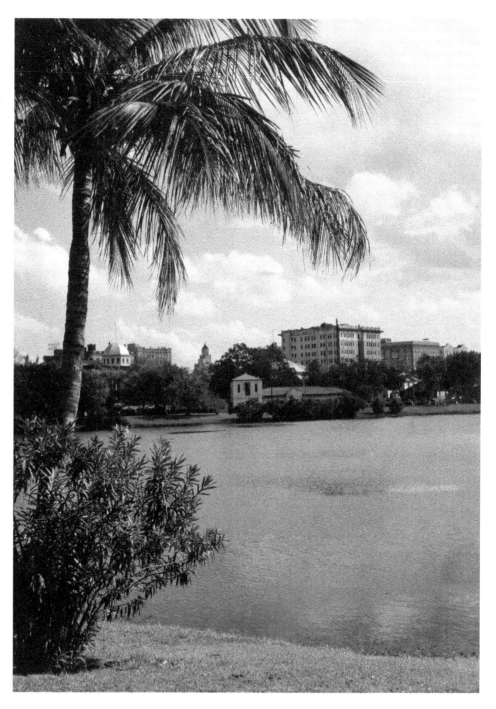

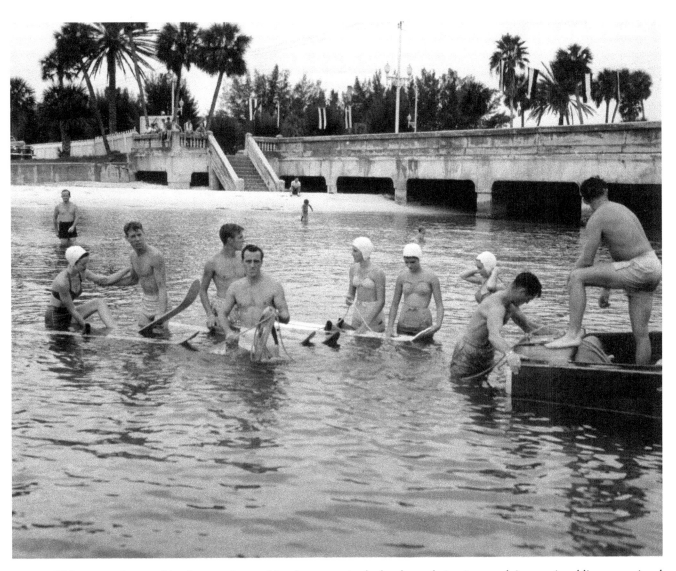

This group of water skiers is preparing to skim the waves. As the local population increased, interest in adding recreational activities also rose. This Jaycee activity was one of many recreational activities they have provided the area since 1933. Others include the Soap Box Derby, the Miss St. Petersburg pageant, the Tarpon roundup, and the Mutt Derby.

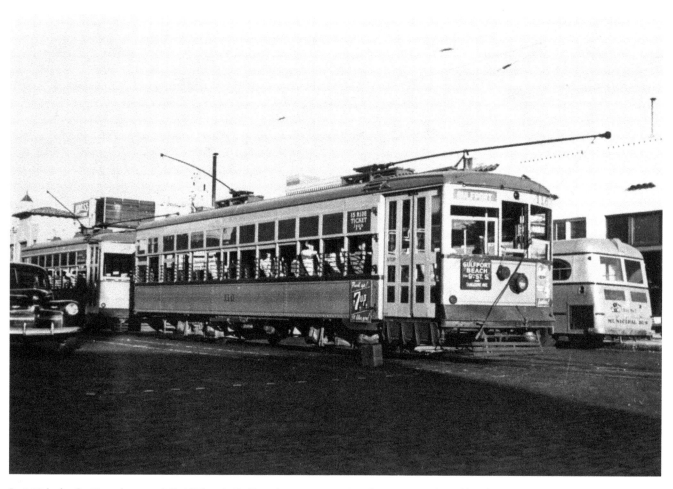

In 1904, the St. Petersburg and Gulf Electric Railway became operational. It was purchased by the city in 1919. The city extended and modernized the transit system in the twenties and replaced most of the streetcars. Many of those same electric trolley cars were still operating when the transit system switched to buses in 1947.

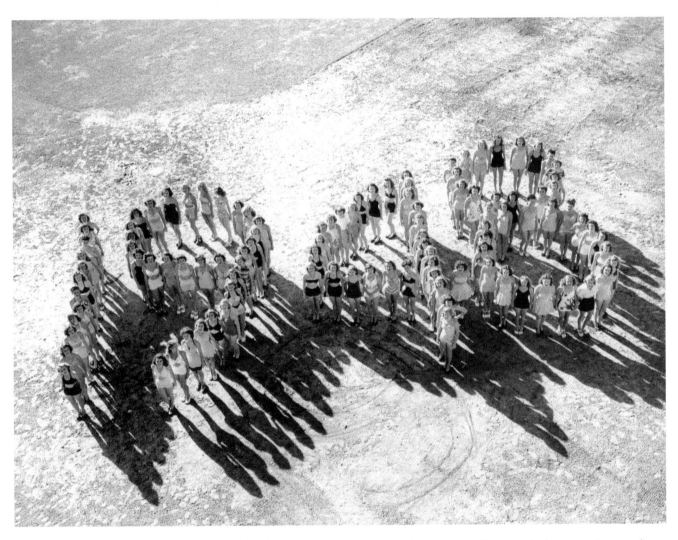

Beauty contestants stage a publicity shot, entitled "entries to charm school for the 1948 year." The year before, Miss St. Petersburg, Eula Ann McGehee, also won the Miss Florida title. St. Petersburg beach and the other beach communities benefited greatly from the postwar recovery of the tourist trade.

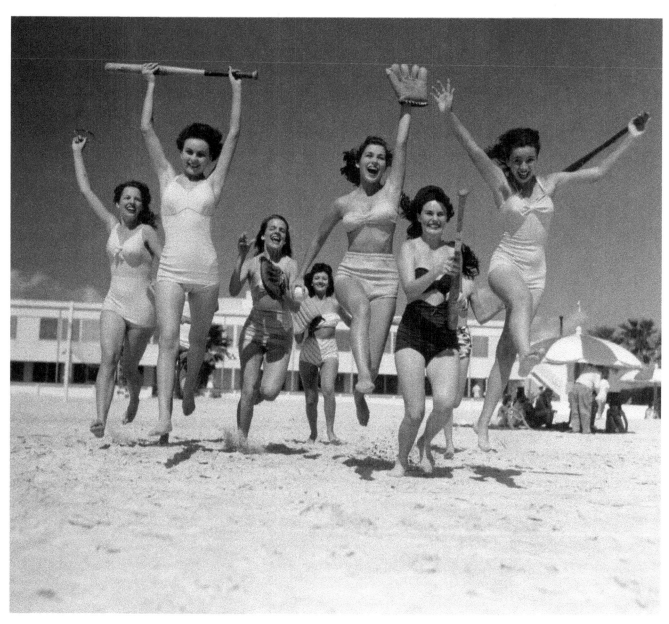

A "baseball team" runs into the surf, on a beautiful sunny day in 1948, for an advertisement promoting the area's world-famous beaches. John Lodwick, the city's chief publicity agent from 1919 to 1942, regarded this promotional approach as a key resource, referring to it as the "Florida fantasy" bathing beauty photograph.

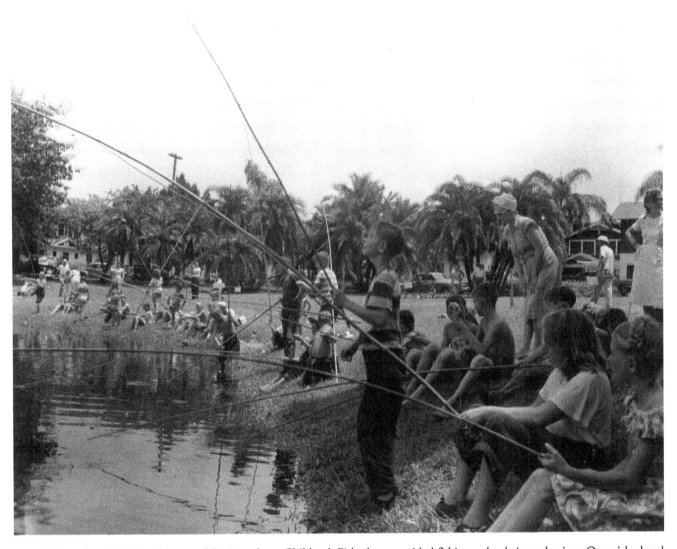

Shown here in 1948, the annual St. Petersburg Children's Fishathon provided fishing poles, bait, and prizes. One girl related that on the morning of the event she asked her father, could she keep the first prize, a bicycle, if she won? The parents had been reluctant to let her have a bike; however, when in fact she won first prize by catching a 2-pound bass, Dad consented.

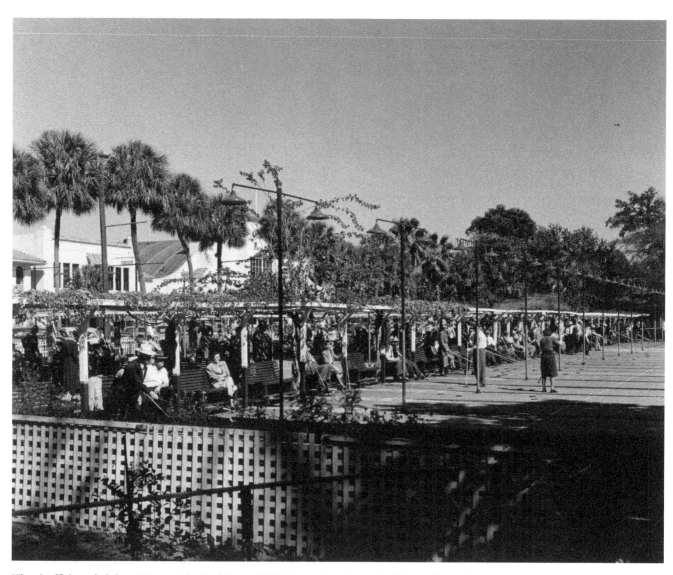

The shuffleboard club at Mirror Lake Park boasted 7,000 members in 1949. Originally built in 1923, the complex has grown to an assembly of 65 masonry courts, 4 buildings, and a grandstand. As city historian Karl Grismer noted, "St. Petersburg wouldn't be St. Petersburg without the shuffleboard courts."

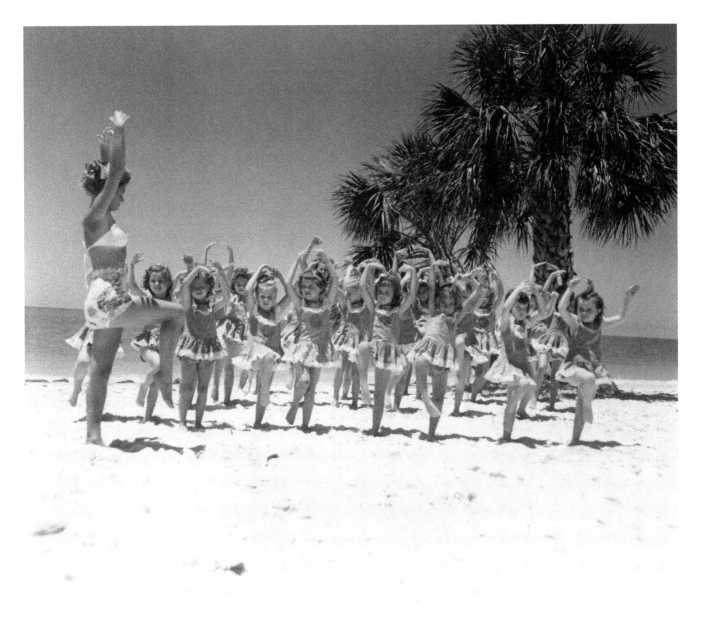

The Eborn School of Dance Art's modeling and ballet class practices on the beach in 1949. Organized children's programs were a valuable community asset. One of St. Petersburg's few dance teachers, Lois Eborn, taught child modeling and ballet. She also had a parasol group, make-up class, and a majorettes and drum-major group.

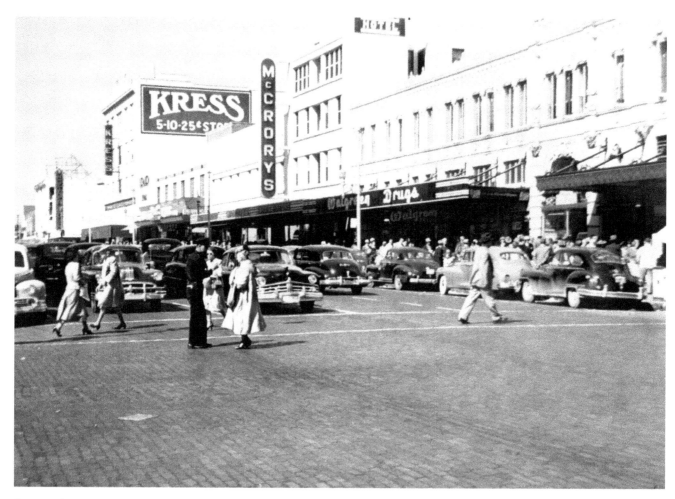

Some pedestrians seem slow to cross Central Street. The 1950 census had revealed significant changes taking place in the community. The population had increased from around 60,000 to 96,000, and the city's profile indicated that it was getting older—22 percent of residents were now older than 65.

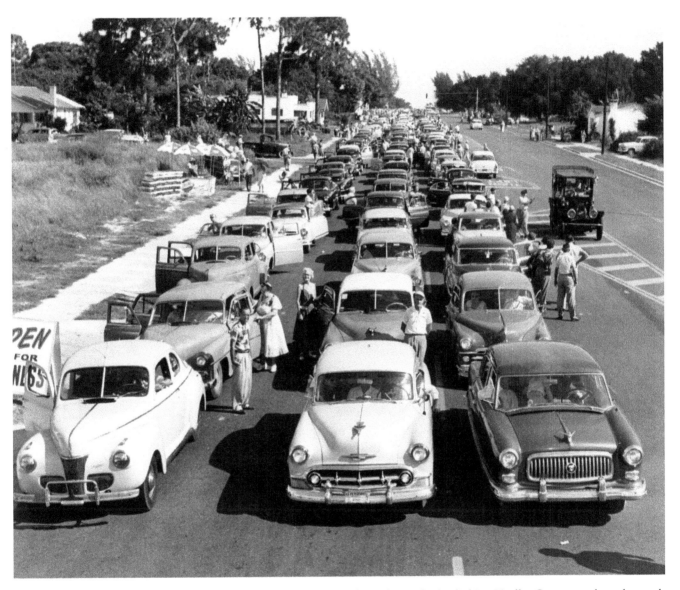

Residents of St. Petersburg eagerly await the opening of the Sunshine Skyway bridge linking Pinellas County roads to the south and Sarasota. Thousands of cars waited on new U.S. 19 to cross the fifteen-mile-long, $22 million bridge. It was a toll bridge, but was free until 11:00 P.M. More than 15 thousand vehicles made the trip in the first 11 hours.

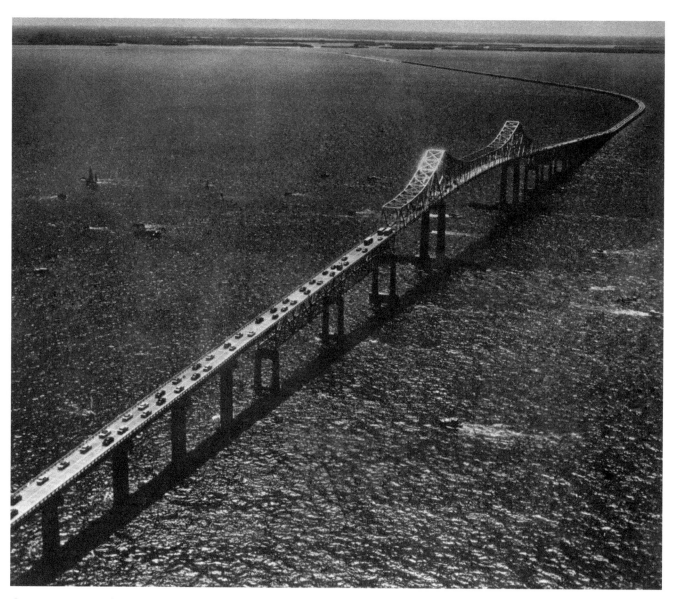

Construction started in 1950 on the original Sunshine Skyway Bridge, to replace the old Bea Line Ferry. It opened with a dedication ceremony on Labor Day 1954 and is shown here in 1955. A second span was completed in 1971 but was struck by the *Summit Venture* in 1980, taking 35 lives. A new Sunshine Parkway Bridge was dedicated February 7, 1987.

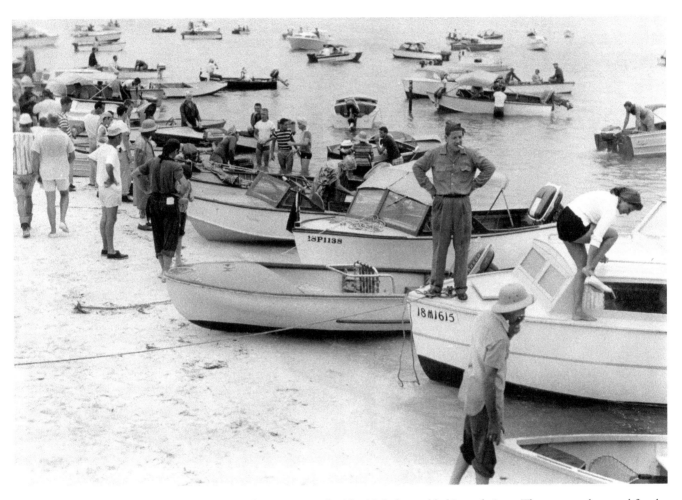

Boaters prepare to embark on a treasure hunt, equipped with pith helmets, khakis, and cigars. The suggested apparel for the Sunshine City: women should wear pedal pushers, shorts, and bathing suits; sports clothes for men; and for the children—let them go barefoot!

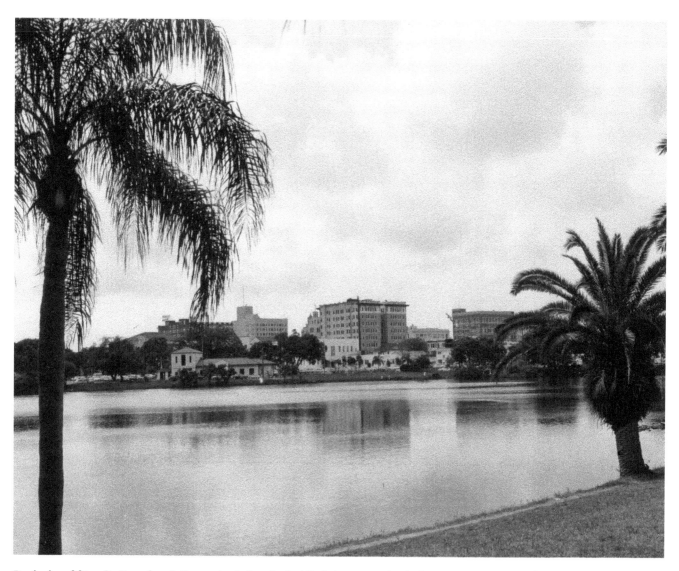

By the late fifties, St. Petersburg's first major industries had little impact on its skyline. Four aerospace industries had built plants in the outlying areas, adding more than 4,000 jobs. In 1959, the city had a population of around 180,000, among which were 83,700 employees earning an average of $2,863 a year.

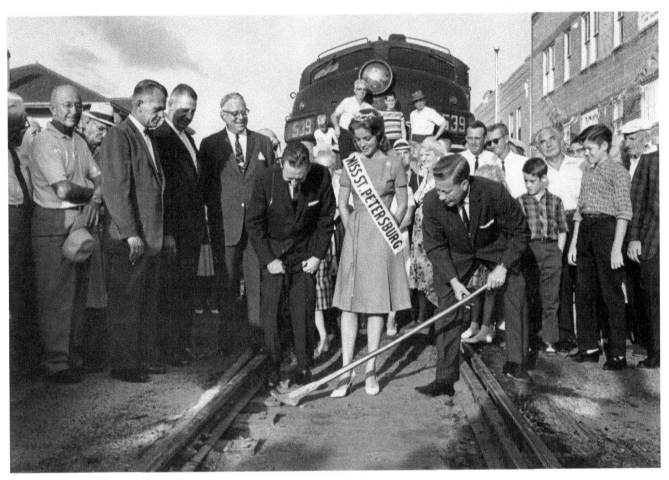

Although the railroads were instrumental in the founding of St. Petersburg, in the early 1960s the city pushed to remove the lines from downtown because the First Avenue track was hindering expansion. In this 1963 ceremony, the last train leaves downtown as Miss St. Petersburg, Diana Gregory, watches Mayor Herman Goldner pulling up a railroad tie.

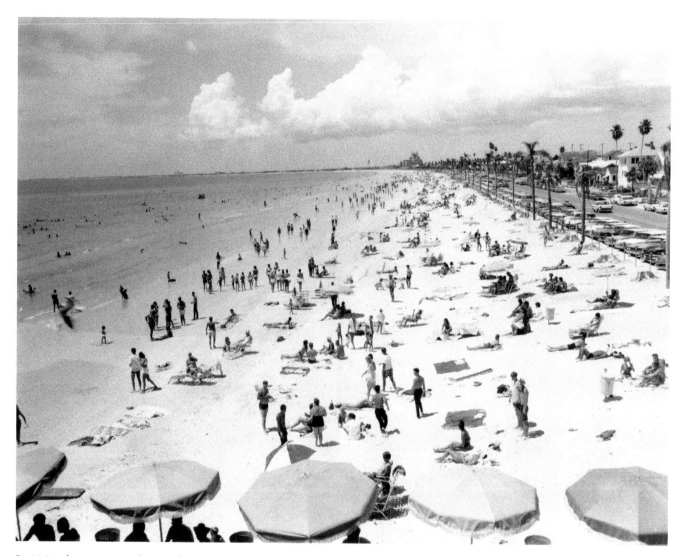

In 1950, the entire population of Long Key numbered only 3,293; by 1960 it had risen to nearly 20,000, prompting a push for consolidation. Despite heavy opposition the measure passed, by only five votes. On July 9, 1957, Belle Vista, Pass-A-Grille, Don CeSar Place, and "old" St. Petersburg Beach were consolidated to become the new St. Petersburg Beach.

NOTES ON THE PHOTOGRAPHS

These notes, listed by page number, attempt to include all aspects known of the photographs. Each of the photographs is identified by the page number, a title or description, photographer and collection, archive, and call or box number when applicable. Although every attempt was made to collect all data, in some cases complete data may have been unavailable due to the age and condition of some of the photographs and records.

II SKYLINE 4
Courtesy of St. Petersburg Museum of History
RC19753

VI EARLY FLYING BOAT
Courtesy of St. Petersburg Museum of History
P00056

X GENERAL STORE 6
Courtesy of St. Petersburg Museum of History
P02174

2 DERAILMENT 7
Courtesy of St. Petersburg Museum of History
P00012

3 WOMEN'S RELIEF CORPS 8
Courtesy of St. Petersburg Museum of History
P07382

DETROIT HOTEL 9
Courtesy of St. Petersburg Museum of History
P00920

SANFORD & ST. 10 PETERSBURG RAILWAY
State Archives of Florida
RC12940

SIXTH AVENUE, 1897 11
State Archives of Florida
203

ORANGE BELT RAILWAY PAVILION 12
State Archives of Florida
RC02302

LAKEVIEW HOUSE 13
Courtesy of St. Petersburg Museum of History
P00288

THE SWALE 14
Courtesy of St. Petersburg Museum of History
P01203

JAMES G. BRADSHAW'S 15 DRUGSTORE
Courtesy of St. Petersburg Museum of History
P00701

CENTRAL AVENUE, 1900 16
Courtesy of St. Petersburg Museum of History
P00437

GOLF COURSE
Courtesy of St. Petersburg Museum 17 of History
P01122

SCHOOL-CHILDREN AT WASHINGTON'S BIRTHDAY
Courtesy of St. Petersburg Museum of History
P01502

FAIR AND 18 WINTER EXPOSITION
State Archives of Florida
RC05677

WASHINGTON'S BIRTHDAY PARADE
Courtesy of St. Petersburg Museum of History
P00573

FIFE-AND-DRUM AND MILITARY CADETS 20
Courtesy of St. Petersburg Museum of History
P01750

CLASSROOM, 21 1902
Courtesy of St. Petersburg Museum of History
P06991

DOMESTIC SCIENCE AND MANUAL TRAINING SCHOOL
Courtesy of St. Petersburg Museum of History
P00215

ORANGE BELT 19 RAILWAY AND PIER
State Archives of Florida
RC05681

EFFIE STONE ROLFS
State Archives of Florida
N048854

FIRST NATIONAL BANK
State Archives of Florida
RC19745

22 OX CART
State Archives of Florida
RC05678

BIBLIOGRAPHY

Allyn, Rube. *Visitor's Guide to Attractions on the Florida Suncoast.* St. Petersburg: Great Outdoors, 1966.

Arsenault, Raymond. *St. Petersburg and the Florida Dream, 1888-1950.* Gainesville: University Press of Florida, 1996.

Atchley, J. F. *This Week in St. Petersburg.* Arcade City, Fla.: J. F. Atchley Pub., February 20, 1935.

Deese, A. Wynelle. *St. Petersburg, Florida: A Visual History.* Charleston, S.C.: History Press, 2006.

Fuller, Walter Pliny. *St. Petersburg and Its People.* St. Petersburg: Great Outdoors Pub. Co., 1972.

———. *This Was Florida's Boom.* St. Petersburg: Times Pub. Co., 1954.

Gould, Rita Slaght, and Diane Stewart Tonelli. *Pioneer St. Petersburg: Life in and Around 1888 "Out Near the Back of Beyond."* St. Petersburg: Page Creations, 1987.

Grismer, Karl H. *The Story of St. Petersburg: The History of Lower Pinellas Peninsula and the Sunshine City.* St. Petersburg: P. K. Smith, 1948.

Gulfport Historical Society. *Our Story of Gulfport, Florida.* Gulfport, Fla.: Gulfport Historical Society, 1985.

Hartzell, Scott Taylor. *St. Petersburg: An Oral History.* Voices of America. Charleston, S.C.: Arcadia Pub., 2002.

Hurley, Frank T. *Surf, Sand, and Post Card Sunsets: A History of Pass-a-Grille and the Gulf Beaches.* St. Petersburg Beach: Hurley, 1977.

Jackson, Page S. *An Informal History of St. Petersburg.* St. Petersburg: Great Outdoors Pub. Co., 1962.

Meade, Marion. *Buster Keaton: Cut to the Chase.* New York: HarperCollins, 1995.

Pass-a-Grille: A Patchwork Collection of Memories. Women's Fellowship of Pass-a-Grille Beach Community Church, 1981.

Pinellas County (Fla.) Dept. of Planning. *Historical Background of Pinellas County, Florida.* Clearwater, 1968.

St. Petersburg and Florida's Gulf Coast: Official Guide. St. Petersburg: Griffith Advertising Agency, 1935.

St. Petersburg, Florida: By the Gulf-Stream, in the Land of Health, Opportunity and Fulfilment. St. Petersburg Board of Trade, 1908.

St. Petersburg, Florida: The Sunshine City. St. Petersburg Board of Trade, 1912.

St. Petersburg, Florida: The Sunshine City. St. Petersburg: Chamber of Commerce, 1921.

St. Petersburg, Florida: The Sunshine City. St. Petersburg: Chamber of Commerce, 1928.

Seeing St. Petersburg: A Book of Information for Visitors. Tourist News Pub. Co., 1924.

Straub, William L. *History of Pinellas County, Florida, Narrative and Biographical.* St. Augustine, Fla.: Record Co., printers, 1929.

Printed in the USA
CPSIA information can be obtained
at www.ICGtesting.com
JSHW072059200524
63505JS00004B/13